IMAGES
of America

SNOW HILL

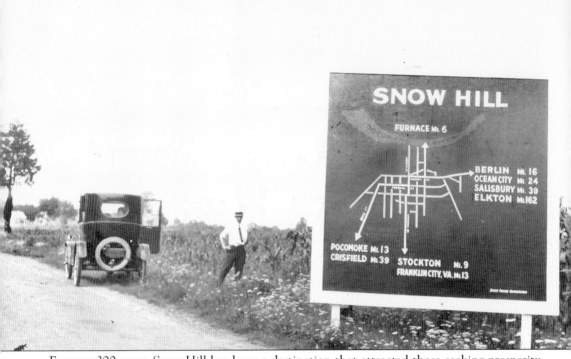

For over 300 years, Snow Hill has been a destination that attracted those seeking prosperity, new ventures, a peaceful home, or rest and relaxation. From the first farmers to the watermen, merchants, ship builders, factory owners, craftsman, politicians, and those seeking an escape from the big cities, Snow Hill, often referred to as "the treasure of the Eastern Shore," has been and is a place to come to—to live, to work, and to experience. (Courtesy of Janet Carter.)

ON THE COVER: This image depicts members of the Snow Hill Volunteer Fire Company in front of the Municipal Building, which served as the fire company's headquarters. Firemen are identified on page 102. (Courtesy of the Julia A. Purnell Museum.)

IMAGES
of America

SNOW HILL

Mindie Burgoyne

ARCADIA
PUBLISHING

Published by Arcadia Publishing
Charleston SC, Chicago IL, Portsmouth NH, San Francisco CA

Printed in the United States of America

Library of Congress Catalog Card Number: 2006929118

For all general information contact Arcadia Publishing at:
Telephone 843-853-2070
Fax 843-853-0044
E-mail sales@arcadiapublishing.com
For customer service and orders:
Toll-Free 1-888-313-2665

Visit us on the Internet at www.arcadiapublishing.com

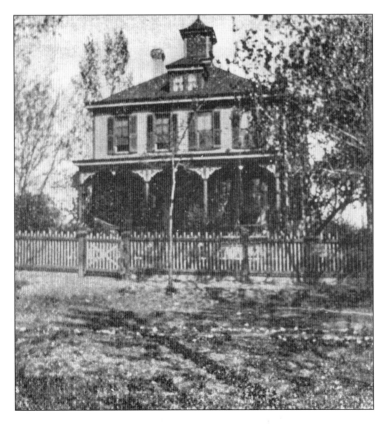

This book is dedicated to Dick and Kirsten DeAngelis, the owners and caretakers of the Alfred Pinchin House on Federal Street (pictured). Their enthusiasm for preserving heritage is remarkable; their commitment to friendship unparalleled. My memories of Snow Hill will always include them.

CONTENTS

ACKNOWLEDGMENTS

Huey Brown, devoted champion of Snow Hill history, generously lent me his collection of photographs, books, periodicals, and notes on Snow Hill and referred me to others who provided invaluable insight and information. Additionally I'm thankful to Bert Gibbons for his photographs and hours of verbal remembrances of the town he was born in some 90 years ago. Thanks to Bill and Blanche Williams, the Julia A. Purnell Museum, the Town of Snow Hill, Charles and Virginia Nelson, Mrs. Virginia Sturgis, Gus Payne, Kathy and Bob Fisher, Cyndy and Danny Pusey, the Reverend Debra Laturre, Emma Scarborough, and Betty Laws for interpretive assistance, photographs, and insights into the past.

My sincerest thanks to Ann Coates for lending me her parents' photograph collection, which chronicled so much of Snow Hill's history, and to Rosemary Corddry Manning, who entrusted family photographs to me that were vital to this book. The support of the Worcester County Library was invaluable as over 70 photographs in this book came from their archives. I was fortunate to work with and include images and postcards from the collections of Janet Carter and John Layo of Snow Hill. Extra thanks go to John Layo, who allowed me to take his postcards home after my scanner and computer exploded in his kitchen, and to Arcadia's Southern publisher, Lauren Bobier, who was patient when the project was delayed due to the explosion in John's kitchen.

Dick and Kirsten DeAngelis gave material as well as encouragement and support for this project, but more importantly, the DeAngelises always give me a good reason to return to Snow Hill. They are dear friends who stood by me during difficult times and provided laughter, counsel, and interesting conversation.

Finally my deepest thanks I give to my husband and best friend, Dan Burgoyne, who has patiently listened while I rambled about Snow Hill, silently waited while I was writing and rewriting this book, and laughed at stories he's heard repeatedly as if they were the first time recited, all out of love for me.

INTRODUCTION

Snow Hill has two distinctions in Worcester County—first that it serves as the county seat and second that it is the county's oldest chartered community tracing its municipal history back 300 or more years. Founded by English settlers who most likely named Snow Hill after a division of the city of London, the town received its first charter on October 26, 1686, and was made a royal port of entry in 1694. Prior to 1742, when Worcester County was carved out of Somerset County and Snow Hill made the county seat, the town had been a trading post and the head of navigation on the Pocomoke River.

The town's 300-year history shows consistently that agriculture and commercial industries, which included shipbuilding, lumber mills, canneries, factories, and more, shaped the economy with the assistance of the Pocomoke River and later the railroad. These two modes of transportation opened endless markets, offering the means to export what was grown and manufactured and to import goods to perfect the trade system. The wealth generated by industry caused the residential population to grow and churches, schools, and businesses to multiply, meeting the needs of a growing community.

Snow Hill became a town of gracious living, where merchants, bankers, lawyers, farmers, and sea captains built fine homes showing off their prosperity. The streets in Snow Hill are lined with historic homes, some dating back to the 18th century, which are fine specimens of Federal, Greek Revival, Victorian Second Empire, Italianate, Queen Anne, and Gothic Revival–style architecture, much of which has been immaculately restored. Of all existing communities, Snow Hill has the largest number of stately homes on the Lower Eastern Shore.

Clayton Torrence in his book *Old Somerset*, written in 1935, comments on Snow Hill: "With its long, straight shady streets laid out at right angles, Snow Hill is peaceful, gracious, and self-conscious. Thus it was that the town of Snow Hill, then in Old Somerset County, now in Worcester County (by subdivision in 1743) had its origin and founding in 1684–1686, and has had a consecutive history of life on the same site for two centuries and a half. The town of Snow Hill became in reality the 'metropolis' of Old Somerset." The development of Snow Hill differed from other towns on the Eastern Shore. There does not seem to have been any significant lot accumulation by any individual beyond 3 or 4 lots and certainly not the same 8- or 10-lot town estates found elsewhere. Additionally, the variety of craft specialists owning Snow Hill lots was unusual. Snow Hill lots were owned by merchants, innkeepers, and planters, as in other towns, but also at different times by shoemakers, barbers, surgeons, cabinetmakers, joiners, blacksmiths, and felt makers. Because the majority of records were destroyed in the courthouse fire of 1893, there is a possibility that many additional types of crafters were also lot owners. Snow Hill also showed an unusual intensity of development—indicated through its lot subdivision, in which a single, legally distinguished lot was broken into two or more parts. Fifteen of the 38 identified lots for which conveyances exist were subdivided, comparatively high in relation to other Eastern Shore towns.

Snow Hill became an attractive place for craft specialists, who became markedly successful not only because of the local population but also due to the town's proximity to a navigable river

that allowed both import and export of goods. Successful craft specialists prospered, and as a result, they were able to afford lots of their own and the ability to build remarkable dwellings. The Pocomoke, and later the railroad, not only allowed export opportunities for craft trades, it also allowed expanded opportunities to import raw materials for those craft trades. Opportunity led to innovation, which led to wealth, which led to development and the establishment of Snow Hill not as just an industrial hub for the area, but also as a center for culture and refinement.

The town claims many notable politicians, artists, clergymen, military men, and sports stars who have been recorded in the annals of American history. William "Judy" Johnson, born in Snow Hill, was the first African American to be admitted to the Baseball Hall of Fame. Snow Hill native John Walter Smith, a U.S. Congressional senator, was later elected governor of Maryland and built one of the most stately homes in Snow Hill, now referred to as the Governor's Mansion. Revolutionary War hero Col. John Gunby lived in Snow Hill and is buried outside the town limits on the property he once called home. The first Presbyterian community established in the United States was founded in Snow Hill by Francis Makemie, considered a champion for religious freedom and the founder of Presbyterianism in America. At age 85, artist Julia A. Purnell began doing needlework scenes, many of which were of Snow Hill landmarks. Her son, William, crafted wooden frames for the needlework and used her art as the foundation for a museum that now holds thousands of early-American artifacts, which have been remarkably interpreted and displayed at the Julia A. Purnell Museum on Market Street.

By the 19th century, Snow Hill had also become a popular destination for travelers. The beach and attractions at Public Landing were second to none in their day. Prior to its destruction by the storm of 1933, Public Landing, with its amusement park, beaches, and cottages, drew visitors from Maryland, Virginia, Delaware, Pennsylvania, and beyond. It offered opportunities for hunting, fishing, and boating. Hotels, restaurants, and stores sprang up in the downtown area of Snow Hill to accommodate travelers and take advantage of the population swell during the tourist season.

Though Public Landing vanished, giving way to Ocean City as the main tourist draw for the Lower Shore, and though the old familiar faces that pioneered the development of Snow Hill are long gone, the initiative to affirm innovation, advance industry, and attract visitors shapes the strategy of Snow Hill leaders today. The courthouse still anchors the streetscape and is a reminder that county business is a major commerce engine, only now the county seat has jurisdiction over more than 46,000 residents. The Pocomoke River that was the popular trade and travel corridor is no less beautiful but has been transformed into a popular avenue of recreation and been dubbed Maryland's most scenic river. The historic homes, many beautifully restored, still lie on the same street grid established some 300 years ago, but they are now occupied by families—many descendants of the original founding families—who are shaping Snow Hill's future, preserving its historic integrity, and promoting its heritage and environmental beauty.

For 300 years, over 15 generations have lived and died in Snow Hill, carving out a unique community rich in faith and tradition. The spirit of innovation that propelled forward a plethora of industry sectors and artisan trades, forging Snow Hill's prosperous path, still lingers today. However, it is now complemented by a revived interest in heritage, culture, restoration, and expanding tourism initiatives—all with the constant and continued comfort of the scenic Pocomoke River framing the town's landscape.

One

A Community Grows Up on the Pocomoke

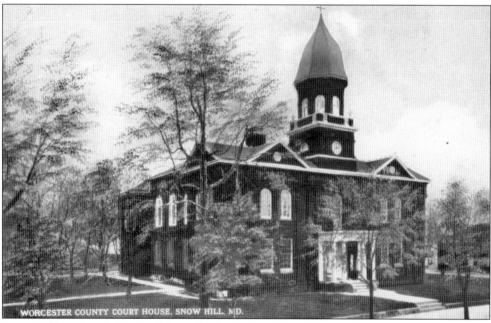

WORCESTER COUNTY COURT HOUSE, SNOW HILL, MD.

Snow Hill was founded by English settlers in the late 17th century in Native American territory, where existing place names reflected the local tribes (Pocomoke, Assateague, Askiminokonson, and Nassawatox). The settlers most likely named the town after the London subdivision Snow Hill. The town received its first charter in 1686 and was established as a Royal Port of Entry by William and Mary of England in 1694. In 1794, Worcester County was created and Snow Hill designated as the county seat. The courthouse that occupies a city block on Market Street today (shown above) replaced an earlier courthouse that was destroyed by fire in 1893 along with most of the records that were housed there. Snow Hill rests at the head of navigation of the Pocomoke River, which opened up avenues for importing goods that could be taxed or exporting goods, including tobacco, cypress lumber, and other manufactured materials. The ability to move goods out to broader markets and import new raw materials and goods for sale created wealth and prosperity and established Snow Hill as a hub of commerce and culture. (Courtesy of Janet Carter.)

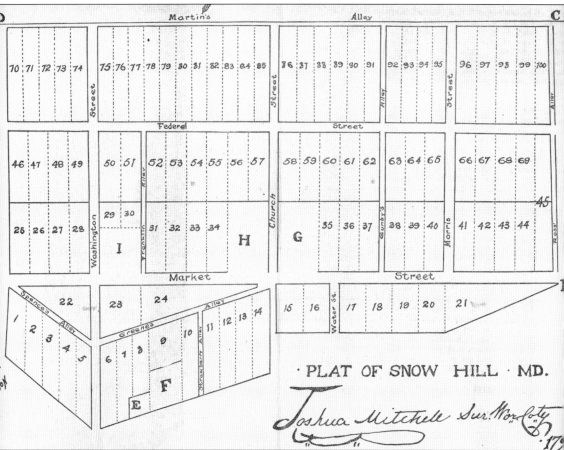

The first plat of Snow Hill, shown here, dates to 1793. The town is divided into 100 lots with 12 streets—the same 12 that are the principal streets today with Federal and Church Streets marking the center. Snow Hill is rare in that the original lot division did not include massive lot accumulation creating large estates. Further subdivision of the original lots into four or more lots marks times of population and economic growth. The Pocomoke River borders the north side of town. Originally the river ran nearly up to where Market Street is today. Eventually a sandbar built up at the end of Washington Street, and the town eventually used that bar to begin reclaiming the land that is now between Market Street and the river, the same land where the commercial district now sits. (*Snow Hill Charter and Code Book of May 1912*, courtesy of Ann Coates.)

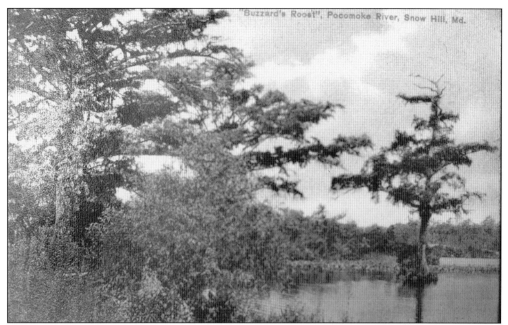

It has been frequently claimed that the Pocomoke River is the deepest river for its width in America. The depth allowed schooners and other large boats to navigate up the river to Snow Hill to pick up items for export, which included agricultural products such as tobacco and lumber. Eventually steamboats navigated the Pocomoke, bringing passengers to and from other cities including Baltimore. The area of the Pocomoke River in the picture above is called Buzzard's Roost. (Courtesy of Worcester County Library.)

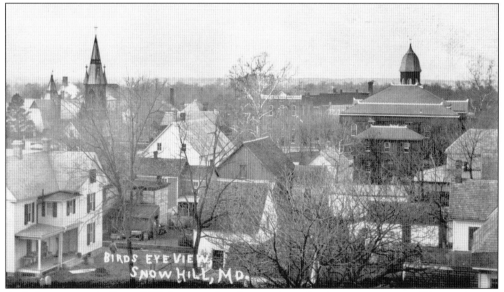

As industry grew in Snow Hill, houses, churches, and new businesses sprang up. The residential houses ran the gamut of small, working-class houses to fine stately homes. There are numerous church communities in Snow Hill. Notice the Gothic spire of Makemie Presbyterian Church on the left and the courthouse tower. This photograph is taken from the southern end of town sometime after 1930. (Courtesy of Janet Carter.)

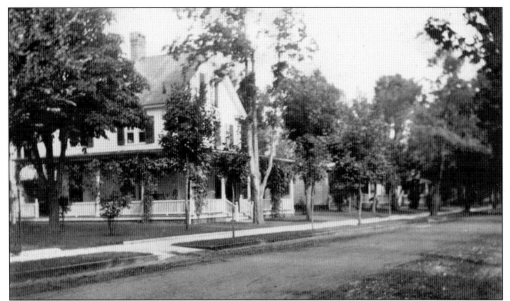

Church Street, one of the defining streets in the Snow Hill plat, was named for All Hallows Church, which was located at its base. The street was laid out to be wide for traffic and transport. Along Church Street are a mix of working-class and stately homes—the larger homes being closer to the town center. Above is the Mariner home on Church Street. (Courtesy of Randall and Joanne Mariner.)

Federal Street crosses Church Street one block into town. Running east to west, Federal Street has some of the most stately homes in Snow Hill lining both sides of the street. The roadway is wide like Church Street and still has some of its original brick, herringbone-patterned sidewalks. Many of the homes have been beautifully restored. In this 1913 photograph looking east from Morris Street, the cupola of the Hargis House (also known as the William Wilson House) can be seen at the right of this photograph, and an early-century automobile can be seen coming west up Federal Street. (Courtesy of Worcester County Library.)

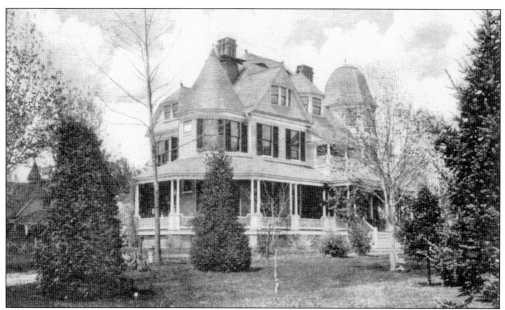

Located on Church Street, the John Walter Smith house or Governor's Mansion is a Queen Anne–style Victorian with 10,000 square feet of living space. It was built in 1889 by Maryland's 44th governor. The mansion has a slate-covered roof that includes two round towers. Baltimore architect Jackson C. Gott was commissioned to design the mansion, which is one of the most elaborate Queen Anne–style homes ever erected on the Eastern Shore. This photograph dates to 1913. (Courtesy of Janet Carter.)

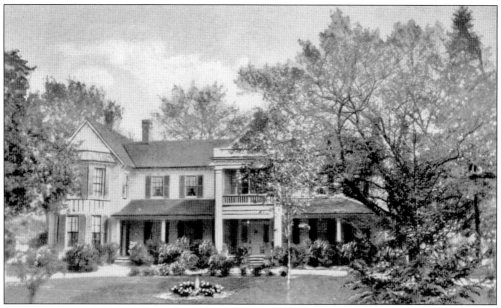

On Federal Street, the Cedars is a rare, large, two-story home. The house was built around 1850 by attorney Walter P. Snow on land belonging to his wife, Ann E. Wilson. There is a combination of styles incorporated in this T-shaped home. The Tuscan columned portico was added later. This house is a prime example of how wealth spread in the mid-19th century with the building of lavish homes. (Courtesy of Janet Carter.)

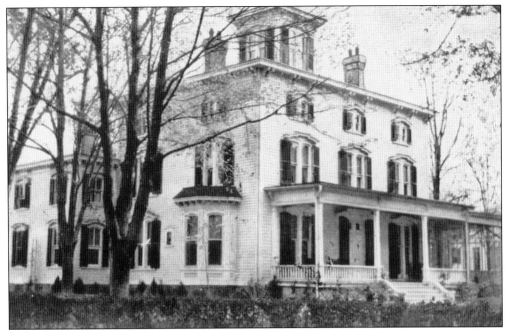

The Hargis House, c. 1881, is located on Federal Street. Its ornate details and Italianate style make it a landmark in Snow Hill. The house was built for the son of a U.S. senator and changed ownership several times before being acquired by Snow Hill mayor and department store owner Marion T. Hargis. It was kept it in the Hargis family until the early 1950s. (Courtesy of Worcester County Library.)

The Pocomoke River used to come all the way up to Market Street before the town was able to reclaim additional land for the commercial district. This house, the Purnell-Shockley House, sits on a spot previously occupied by the Market Square and dominates the corner of Market and Church Streets. It was built in 1905. (Courtesy of Janet Carter.)

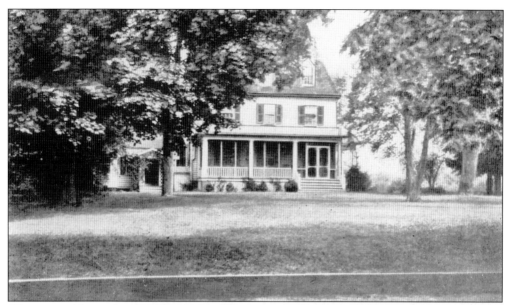

Cherrystone, located at 208 West Federal Street, originally occupied half a city block and faced Church Street. Built in the Federal style in the early 19th century (parts of the house are dated to 1790), Cherrystone sits on some of the highest ground in Snow Hill. It was one of the first dwellings to spring up in the town. The first portion of the house was originally owned by John Ross, rector of All Hallows Church. (Courtesy of Janet Carter.)

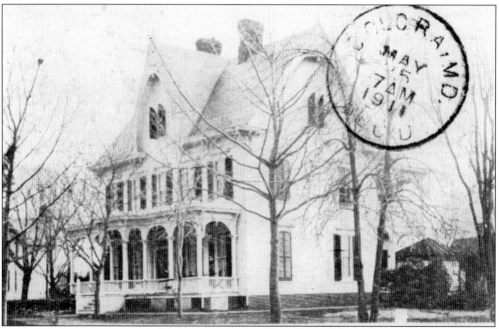

One of the finest examples of Victorian architecture in Snow Hill is represented by Mapleton, a house built by George S. Payne on Federal Street in 1881. The house originally went the depth of a city block and had well-kept gardens (the bones of which can still be seen today) that were later opened to the public. George Payne left it to his two daughters, Nellie and Annie, who lived there until their deaths. (Courtesy of Janet Carter.)

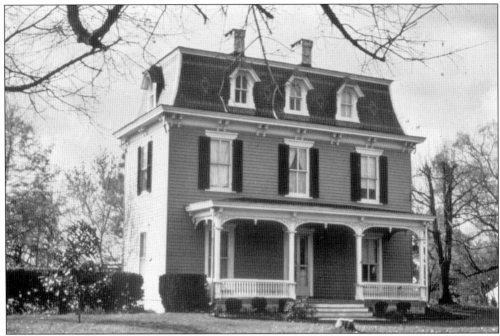

The house above was built in 1885 by John J. Collins, who was a commercial real estate broker and prominent merchant in Snow Hill. This is one of the last historic homes on Federal Street's west end on the south side. It is the only home with a full Victorian mansard roof, which is ornately decorated with colored slate. (Courtesy of Worcester County Library.)

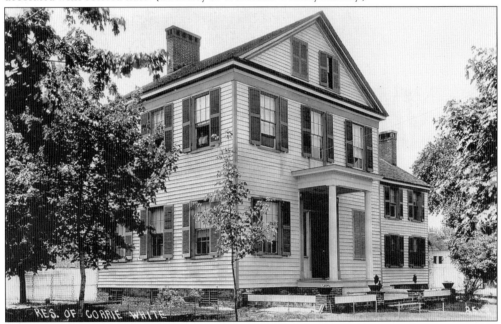

John Purnell Robbins's name is mostly associated with this town house on Market Street across from the commercial district. It was built around 1838 on property that was part of a land grant patented to Col. Robert King in 1746 named "Kings Necessity." (Courtesy of Worcester County Library.)

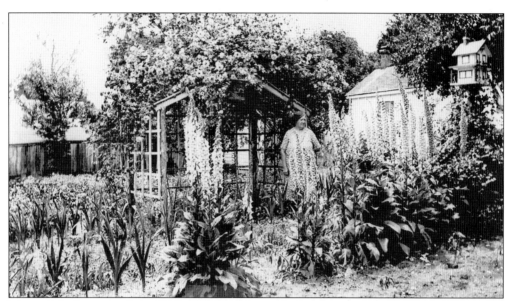

Many of the homes in Snow Hill's residential district had elaborate gardens, as seen in this Snow Hill garden. The gardener is Belle Ritchie, who was a seamstress in town. Her garden has foxgloves over five feet tall. Notice the climbing roses over the arbor. This photograph was taken in the 1930s by Ritchie's nephew, Jim Sturgis. (Courtesy of Ann Coates: the Frances Sturgis Collection.)

This photograph was taken around 1902 at a house that stands on the first block of Church Street. The only subject known in the photograph is the smallest child. Snow Hill citizen Ann Kinstler identified the child as Eleanor "Tookie" Robbins. (Courtesy of Randall and Joanne Mariner.)

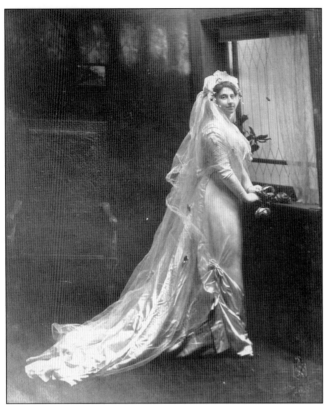

The Snow Hill bride in this photograph is Dr. John Aydelotte's daughter, Mildred. The Aydelotte family lived in a house on Market Street now known as the Snow Hill Inn. Mildred was about to marry an attorney, G. Walter Mapp, who would become a state senator and move her to Accomac, Virginia. It was there that they raised their family. This photograph was taken around 1910. (Courtesy of Margaret Aydelotte Young.)

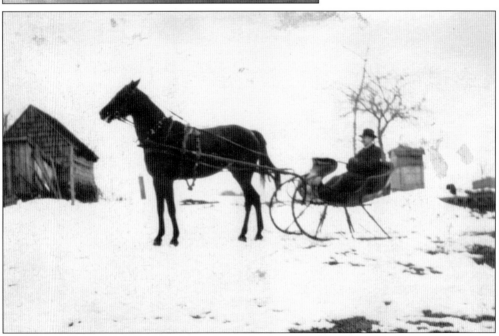

On the rare occasions of snowfall, a horse-drawn sleigh was used in place of the carriage, which was likely to sink in the snow. Pictured here is W. G. Wimbrow in his two-passenger Albany Cutter sleigh dated to the 1920s. (Courtesy of the Julia A. Purnell Museum: the Frances Sturgis Collection.)

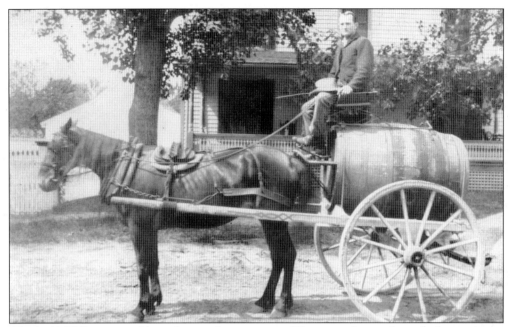

Charles E. Hill is pictured here driving the water cart. Wagons and carts drawn by horses, oxen, and mules were a mainstay of commerce in the early 1900s, as most businesses afforded home delivery. Fresh water was deposited in this barrel, carted around to farms, businesses, and residents, and sold by the cup or bucket to homes, farms, and workers. (Courtesy of Worcester County Library. Source: Tish Dryden.)

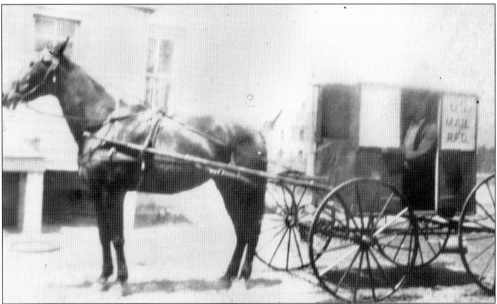

This horse-drawn mail carrier is typical of the first rural carriers used to deliver mail. When the United States Rural Free Delivery Service was established in 1896, Robert E. Hickman of Snow Hill was the nation's first official rural mail carrier. Hickman also owned the first enclosed mail carriage, like the one pictured above. Otis Northam is the driver pictured here in 1900. He had routes on the north and west sides of the river. (Courtesy of Worcester County Library.)

In the early 20th century, communication that was not done face-to-face was done by mail. Postcards not only provided a way to send news home from faraway places; they also allowed neighbors and relatives to keep in touch who only lived miles away from each other. It was not uncommon for a daughter to jot a note on a postcard to her mother across town with a short message about current family news or an inquiry after health. The writer of the postcard could put a stamp on the card and give it to the postman when he delivered the mail. The same postman would deliver the card when he got to that house, which was most likely on his route. A letter posted one day would often arrive the same day if mailed in town. The postcard business was a thriving industry. (Courtesy of John Layo.)

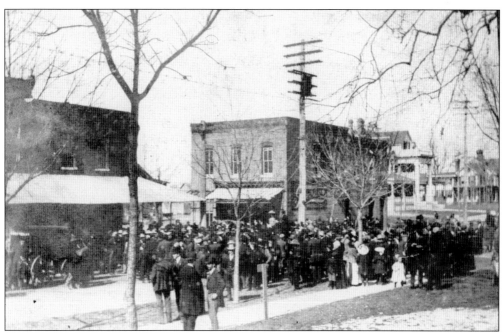

Market Street originally ran along the market square where most of the trading and commercial business was done. As the commercial district expanded between Market Street and the river, Market Street became the southern border of the commercial center with the courthouse as its anchor. Crowds are shown here gathered at the intersection of Market and Washington Streets in 1910. (Courtesy of Worcester County Library. Source: Elizabeth Sturgis.)

Shown is an early shot of Pearl Street in the commercial district before the streets were paved. The photographer was most likely standing near the Hargis Department Store and the corner of Green and Pearl Streets. This photograph was owned by Eleanor "Tookie" Robbins, who took a fall on Pearl Street and wanted to show others exactly where. (Courtesy of Randall and Joanne Mariner.)

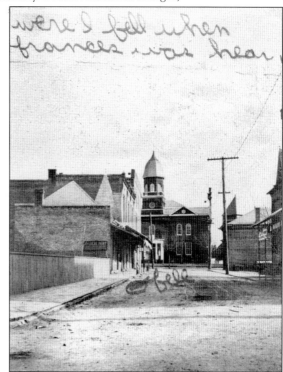

21

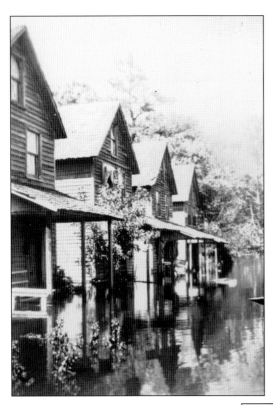

The Chesapeake Potomac hurricane that raged up the Atlantic coast in August 1933 did severe damage to Snow Hill, mostly through flooding. Also known as the "Storm of '33," the hurricane had been downgraded to a tropical storm by the time it hit Worcester County. Shown here is some of the residential flooding. (Courtesy of Worcester County Library. Source: Esther Evans.)

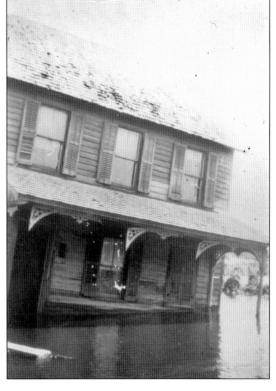

The storm of 1933 created a huge tidal surge that came up the Chesapeake Bay and funneled into the narrow confines of the Pocomoke River. Shown here is a residence in Snow Hill that has been lifted off its foundation by floodwaters and is tilting. (Courtesy of Worcester County Library. Source: Esther Evans.)

In Maryland, the storm of 1933 resulted in 13 deaths and the loss of over 1,000 livestock animals. For the Snow Hill area, the properties closest to the river had the most damage. This shot is taken looking down Bank Street toward the river. (Courtesy of Worcester County Library. Source: Esther Evans.)

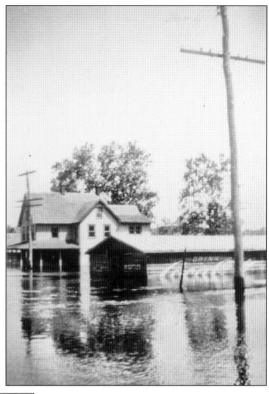

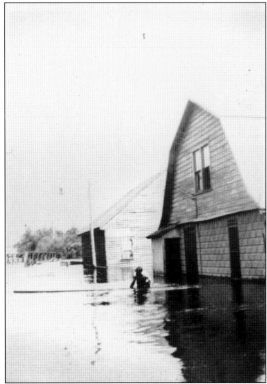

The storm surge that came up the bay was said to be seven feet high with 70-mile-per-hour winds. The man in this photograph, up to his hips in floodwater, looks as if he's trying to retrieve something that floated out of the garage pictured here. (Courtesy of Worcester County Library. Source: Esther Evans.)

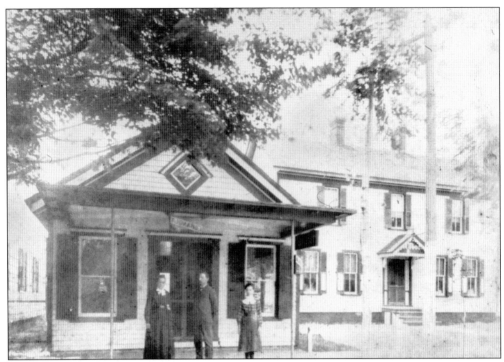

This Washington Street store was built by John Taylor, who is pictured with his wife, Annie, and daughter, Lola. It stood where Old School Baptist Church is now. Taylor also built the house next door. The photograph dates to 1900. (Courtesy of Worcester County Library. Source: Elva Parks.)

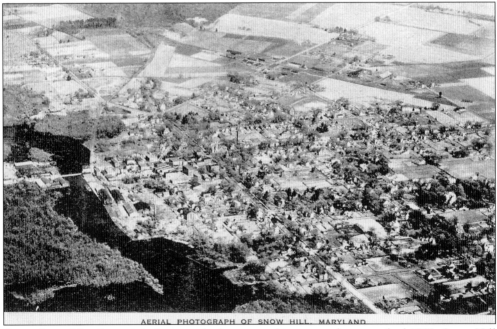

As evidenced by the aerial photograph shown on this postcard postmarked 1938, Snow Hill transformed from a small trading post to a thriving town with industry along the river and a concentrated residential area. (Courtesy of Kenneth "Bert" Gibbons.)

Two

A Hub of Commerce and Government

From the time of its first charter, Snow Hill was able to grow its industry to match the changing times. Most of its success for change came as a result of the town developing modes of transportation that matched the need. Transportation increased market shares. Snow Hill moved forward from its early days when trade exports were fur, tobacco, and Indian corn via the river to exporting lumber, iron, and expanded agricultural products. With the arrival of the railroad in 1868, Snow Hill had an additional means of export with faster delivery. With the prosperity that emerged, financial institutions grew, education was expanded, and successful businessmen were made. Some of these men became historic icons whose names occupy street signs, buildings, and villages. Pictured are several Snow Hill businessmen. The photograph was taken around 1920. In the center of the photograph is Dr. John Aydelotte, who served the state of Maryland as a surveyor and Snow Hill as the town doctor. His home, now known as the Snow Hill Inn, was located near the courthouse on Market Street. He lived to age 87. (Courtesy of Margaret Aydelotte Young.)

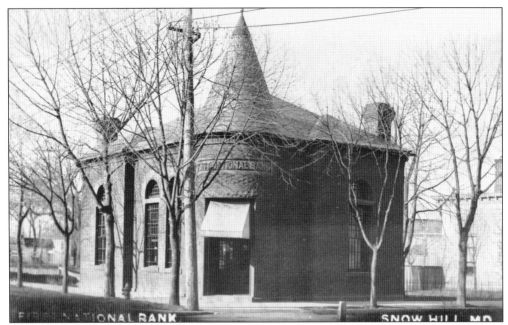

The First National Bank, located at the corner of Bank and Market Streets, opened in 1887 with an initial investment of $50,000 organized under John Walter Smith, once governor of Maryland. It is the longest operating financial institution in Worcester County. In 1926, Snow Hill had three banks, two national and one state. It also had a building and loan association. (Courtesy of Janet Carter.)

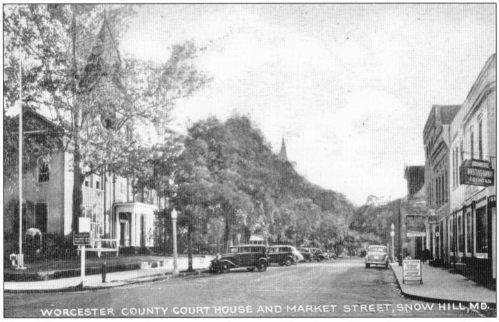

Though businesses prospered in town, agriculture was still an integral part of the economy. Family farms extended outside the town into the county, growing staple crops that were hauled into the town for export. The government for the entire county operated from Snow Hill's town center. This photograph shows Market Street in the 1940s. (Courtesy of Richard DeAngelis.)

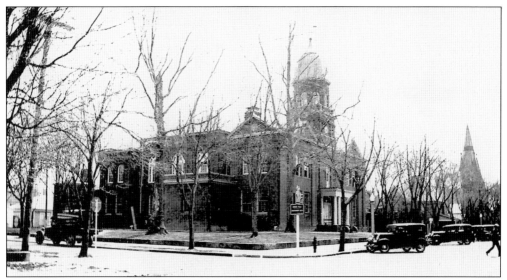

The red brick, Victorian-style courthouse replaced the second courthouse that was destroyed by fire. It has occupied the square in the center of town since 1894 and not only houses the county offices but many of the county records. It was designed by Baltimore architect Jackson C. Gott. This photograph was taken in 1934. (Courtesy of Ann Coates: the Frances Sturgis Collection.)

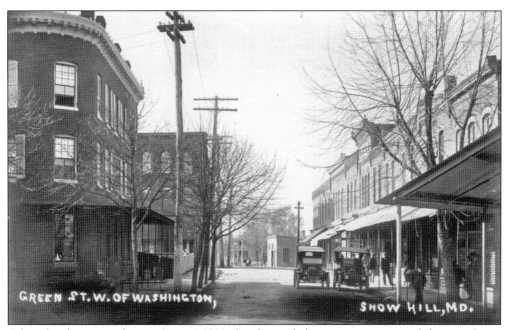

After the disastrous fire in August 1893 that burned the entire commercial district, Snow Hill was rebuilt with buildings made of bricks and stone. This gave more resistance to fire and made for a modern-looking town. The photograph here is of Green Street in 1927. (Courtesy of Janet Carter.)

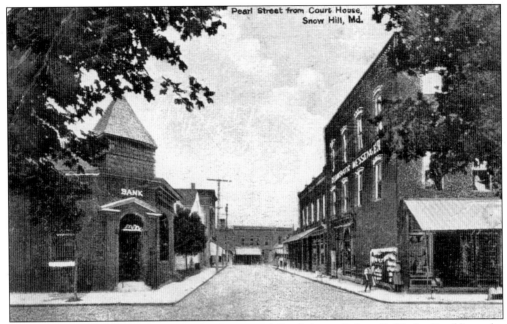

Shown in this photograph are Maryland National Bank (now Calvin B. Taylor Bank) on the left and the *Democratic Messenger* building on the right. These buildings flanked the entrance to Pearl Street from Market Street across from the courthouse. M. T. Hargis Department Store is on the left at the corner of Green and Pearl Streets. (Courtesy of Janet Carter.)

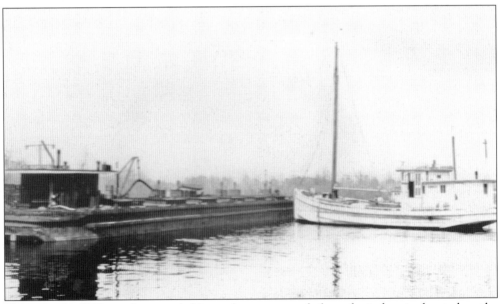

Shown in the 1930s is a barge and ship used to move goods from the industries located on the river. Barges, ships, and steamers ferried goods and people down the Pocomoke River and up to Baltimore, opening up opportunities for expanded commerce and culture. (Courtesy of the Julia A. Purnell Museum: the Frances Sturgis Collection.)

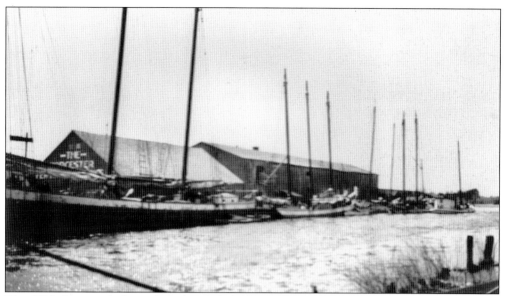

This 1935 photograph shows ships that include the three-masted ram schooners that hauled in raw materials from Baltimore for use by the Worcester County Fertilizer Company. The three-masted ram schooners that came to Worcester Fertilizer were *Edwin and Maude*, *Edward R. Baird*, *Levin J. Marvel*, *J. Blades*, and *Jennie D. Bell*. All were built in Bethel, Delaware. (Courtesy of the Julia A. Purnell Museum: the Frances Sturgis Collection.)

The Dighton Farm was located on the Pocomoke River west of the town off of what is now Dighton Avenue. This photograph was taken in the early 20th century. Former occupant of the farm Harry Bowen stated that the Dighton Farm was once a stagecoach stop between Pocomoke City and Berlin. (Courtesy of Janet Carter.)

This postcard shows the Virgil Pruitt House and outbuildings from across the Pocomoke River. The Pruitt property, located on the west end of Market Street, was adjacent to the Dighton Farm. Pruitt was in the chicken business and invented a feeder that prevented chickens from drowning, which he sold to the chicken industry for a hefty profit. His house is now owned by the Nixon family. (Courtesy of Worcester County Library. Source: Elizabeth Sturgis.)

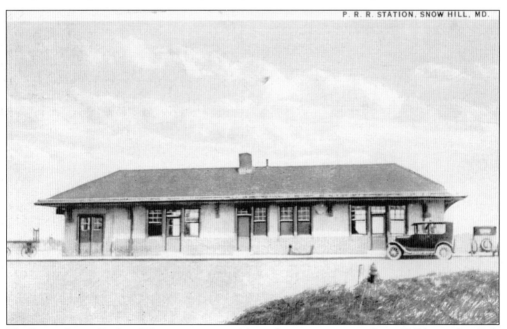

The Pennsylvania Railroad Company operated from the train station in Snow Hill located on Belt Street. Pictured is the passenger station in the 1940s. Lloyd Brittingham's taxis are parked out in front. Though trains do not run through Snow Hill anymore, the train station has been beautifully restored by the town and is now used for public meetings. (Courtesy of Janet Carter.)

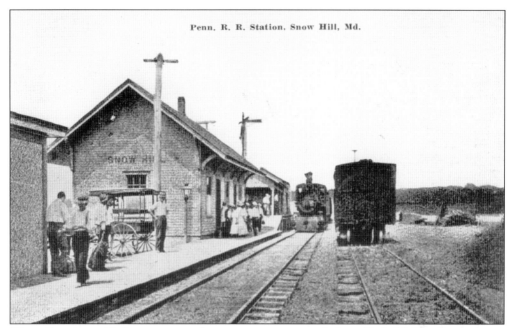

Penn. R. R. Station, Snow Hill, Md.

The railroad provided passenger and cargo services twice daily to Philadelphia. Staple crops, mail, and passengers departed the Snow Hill Station on both these runs. The railroad, which was opened in 1868, first ran along the river and serviced the industries there. The Belt Street station is farther up town. (Courtesy of Janet Carter.)

Frank Fooks (third from left with his arm around his wife, Molly) is shown here with his family departing for Philadelphia at the train station. Fooks was a former mayor of Snow Hill, state legislator, and manager of Worcester Fertilizer. He lived on Federal Street with his family. (Courtesy of Worcester County Library. Source: Sara Barnes Davis.)

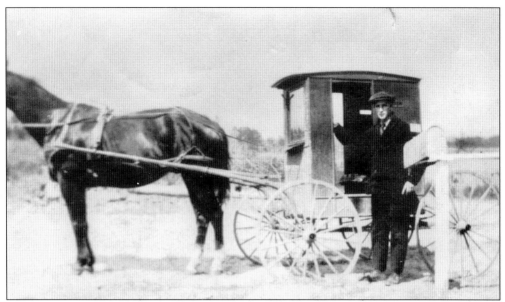

The mail carrier shown in this photograph is Clayton Webb, who was substituting for a carrier named Robinson. Mail was picked up and delivered twice a day in the early part of the 20th century. This coincided with the two railroad runs each day. (Courtesy of the Julia A. Purnell Museum: the Frances Sturgis Collection.)

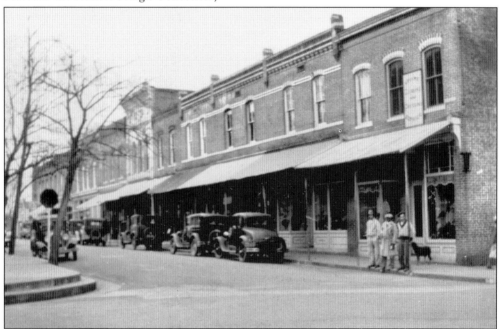

This Green Street photograph shows three men and a dog outside Howard Collins' Men's Shop. The sign above the shop reads "Collins—Cleaning and Pressing Services." Charles Nelson of Snow Hill identified some of the stores: Collins', the American Store, Higgins Drugs, Hudson's Men's Store, Miss Lottie's Hat Shop, Goodman's Department Store, Siegel's Shoe Repair, Moore's Oyster Bar, and G. Marion Dryden Grocery Store. (Courtesy of the Julia A. Purnell Museum: Frances Sturgis Collection.)

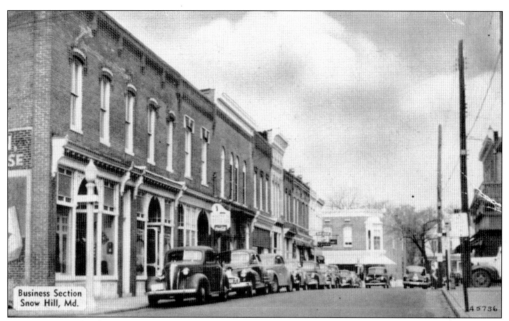

This view is the business district looking down Green Street toward Washington Street. All parking spaces are taken by these early automobiles. The sign hanging from the building on the left reads "Moore's Oyster Bar." The photograph was taken after 1915 and before 1930. (Courtesy of Janet Carter.)

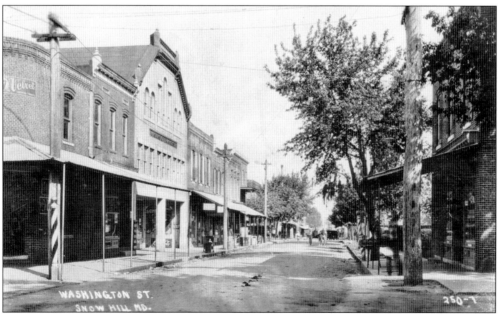

Washington Street extended from the courthouse to the river and across. Shown here is the corner of Market and Washington Streets before roads were paved. The Mason's Opera House Theater is apparent on the left. Telephone poles and wires show that the phone system had been installed. Barely visible in the road is a horse-drawn cart approaching Market with an early automobile behind. (Courtesy of Janet Carter.)

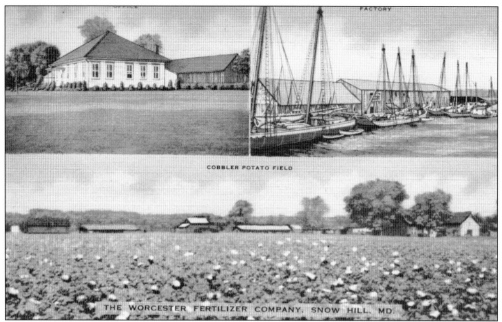

This postcard was an advertisement for Worcester County Fertilizer Company. It shows three views on the front: the office, the factory, and the cobbler potato field. This company began in 1913 and manufactured plant food fertilizers for all crops grown in Snow Hill and the surrounding six-county region. Many of their raw materials were brought in by ram schooners. (Courtesy of Kenneth "Bert" Gibbons.)

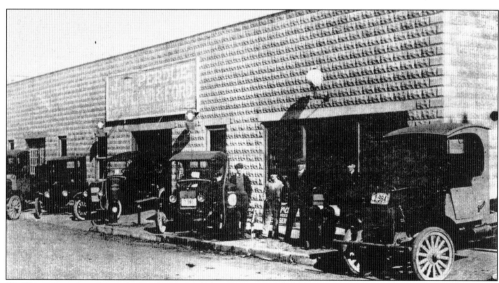

"Selling Overland, Fords, and Buggies" was written on the back of this 1919 photograph. J. H. Perdue is commonly remembered for selling Fords in Snow Hill. His garage, located on Washington Street (near where the Canoe Company stands today) also sold Overlands and buggies. In front are new Ford models.

Three

INDUSTRY GROWS

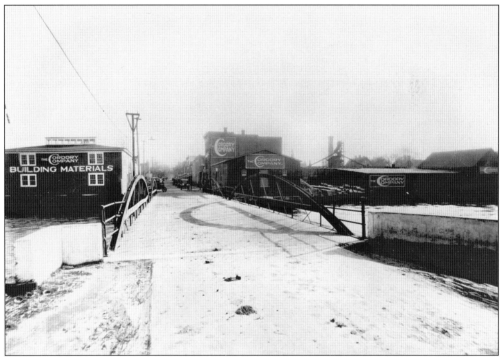

This is the view crossing the Pocomoke River Bridge entering Snow Hill from the Salisbury Road in the 1920s. The Corddry Company, originally named William D. Corddry and Sons, was established in Snow Hill in 1883. The company cut and manufactured lumber, boxes, and building materials and was conveniently located on the river, making export of materials easy. The Corddry Company grew to include a hardware store, storage facility, and coal yard and spawned some of the greatest 20th-century leaders in Snow Hill, including Snow Hill mayors, a state delegate, and leaders in the major financial institutions. Part of the original Corddry Company can still be seen today in the Pocomoke River Canoe Company, which occupies the building in this photograph on the left marked by a sign as Corddry Company Building Materials. In the late 19th and early 20th century, as companies like the Corddry Company, Worcester Fertilizer, and canning companies expanded, jobs were created and Snow Hill was once again propelled forward as a population and industry center. Wealth was generated, homes were built, and the community grew. (Courtesy of Rosemary Corddry Manning.)

William Dickerson Corddry Sr. was born near Laurel, Delaware, and came to Snow Hill at age 18 to learn carriage making from James Messick. He established the Corddry Company in 1883 and was a carpenter and builder by trade. Two of his sons, William Jr. and Charles, went on to run the company. It was William Sr. who changed the spelling of the Corddry name to have two "d's" in order to differentiate his family from the many Cordrys in Delaware. (Courtesy of Rosemary Corddry Manning.)

William Corddry Sr.'s eldest son was William D. Corddry Jr., born July 12, 1863. William Jr. served as the president of Corddry Company, founded the Snow Hill Building and Loan Association, and became founder and first president of the County Trust Company Bank. He also was a state delegate and twice mayor of Snow Hill from 1902 to 1912. He died in 1943 and was the father of Harris Stagg Corddry. (Courtesy of the Town of Snow Hill.)

Charles Wilson Corddry, vice president of the Corddry Company and mayor of Snow Hill, was born in 1871 in Snow Hill and is remembered as a leader of the community who did much to foster the growth of business and guide the town's rise in prosperity. Much of the Corddry Company success is attributed to his keen acumen in business. His second marriage was to Machree Allender, and they had three children. (Courtesy of Rosemary Corddry Manning.)

Machree Corddry, shown here in her engagement photograph at age 21, married Charles Wilson Corddry in Baltimore. They returned to Snow Hill where they lived in a house that still stands on Market Street next to the lot behind the Municipal Building. They had three children—Charles Jr., Rosemary, and Joe—all raised in Snow Hill. (Courtesy of Rosemary Corddry Manning.)

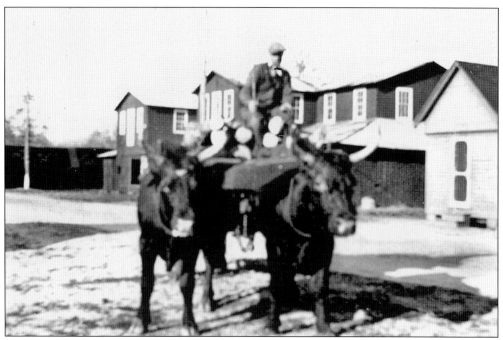

The Corddry Company cut its own lumber, which was often hewn from swampy areas around the Pocomoke River. This photograph, taken in 1935, shows a Corddry lumber cart being pulled by two oxen. Oxen were better suited than horses to draw the lumber out of the swamp. (Courtesy of the Julia A. Purnell Museum: the Frances Sturgis Collection.)

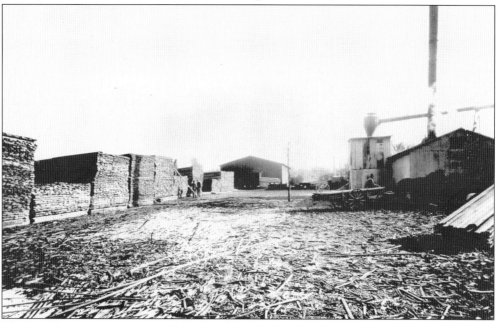

The Corddry Company was originally founded in 1883 under the name W. D. Corddry and Sons as a building material business. After several expansions and acquisitions of other companies, the business was incorporated in 1907 as the Corddry Company. It had several sawmills, and lumber was always its main product. (Courtesy of Rosemary Corddry Manning.)

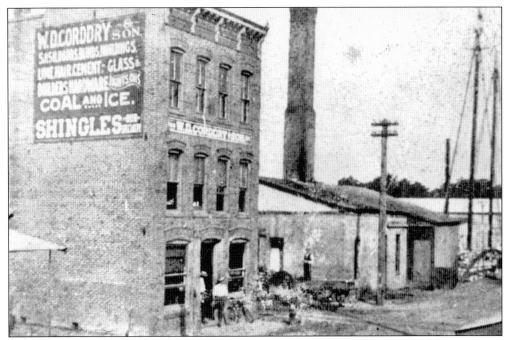

By the early 20th century, the Corddry Company sold ice and coal in addition to building materials and had sawmills and a planing mill. Show here is the Corddry Company Hardware Store, which stood on Washington Street at the north entrance of Snow Hill. The building no longer remains. (Courtesy of Rosemary Corddry Manning.)

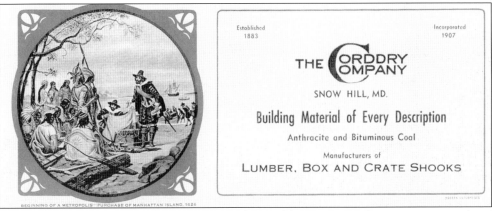

This image is of a promotional blotter featuring the Corddry Company advertising as a provider of building material of every description, anthracite and bituminous coal, and lumber, box, and crate shooks. On the left is a picture entitled "Beginning of a Metropolis—Purchasing of Manhattan Island in 1626." Clearly the Corddry Company was a big economic player at the time. (Courtesy of Rosemary Corddry Manning.)

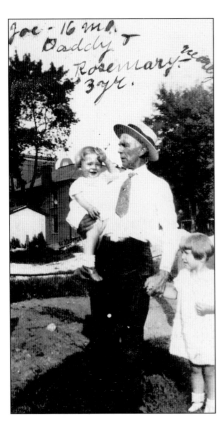

Charles Corddry Sr., shown here with his children, Rosemary (3 years) and Joe (16 months), was known in Snow Hill as a businessman and friend with a sterling reputation for helping others and leading advancements in the town's economic development. It has often been stated that Charles Corddry had no enemies. (Courtesy of Rosemary Corddry Manning.)

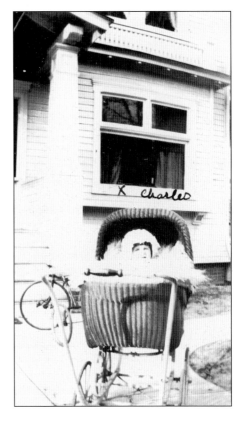

Charles Corddry's daughter, Rosemary, is pictured here at 16 months old in a beautiful wicker pram. The photograph is taken just outside the Corddrys' Market Street home. Adjacent to this photograph in Machree Corddry's album was a poem called "The Rosebud" penned by Machree with the caption "Rosemary—her first piece." (Courtesy of Rosemary Corddry Manning.)

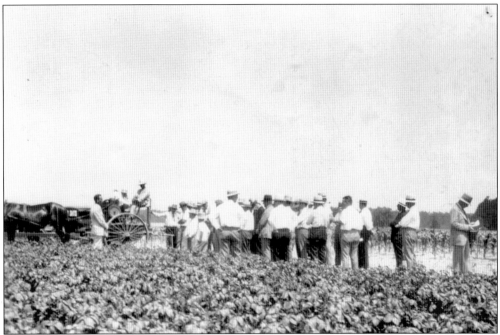

Potatoes were a cash crop in the early part of the 20th century. Potatoes could be pulled from the fields (as seen in this image), iced down, and taken to the railroad station where they could be in Philadelphia by the end of the day. The market for potatoes before the Depression was huge, and farmers in Snow Hill prospered. (Courtesy of the Julia A. Purnell Museum.)

Shown in this photograph is a salesman who was marketing a "potato digger" tool to local Snow Hill–area farmers. After the Depression, the market for potatoes shrank dramatically, and many Snow Hill potato farmers suffered, some even losing family farms that went back many generations. (Courtesy of the Julia A. Purnell Museum.)

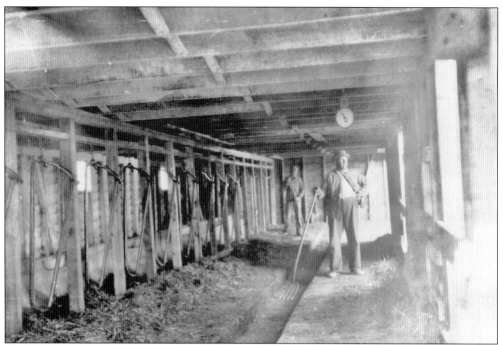

The stanchions, like those pictured, were used by dairy farmers to secure their cows while being milked. This photograph dates from the 1930s and is of a local Snow Hill dairy farm building with two unidentified men with pitchforks cleaning the area. (Courtesy of the Julia A. Purnell Museum.)

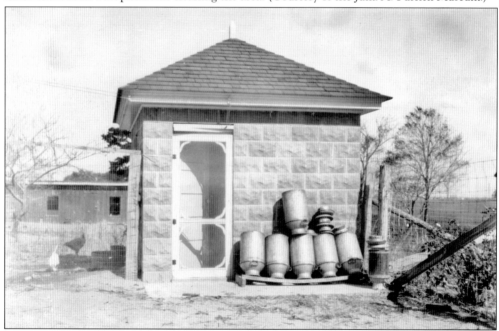

Dairy farming was all done by hand in the early 20th century. After cows were milked by hand, the milk was strained and then placed into metal milk cans, like the ones pictured. They were then placed in the block building, like this one, to be cooled down before being transported. (Courtesy of the Julia A. Purnell Museum.)

After the milk in the cans was properly cooled, the cans would be loaded onto a cart, like the one shown in front of this block building, and wheeled down to the main road, where a truck would pick up the cans and take them to the railroad milk station to be shipped twice a day to Philadelphia. (Courtesy of the Julia A. Purnell Museum.)

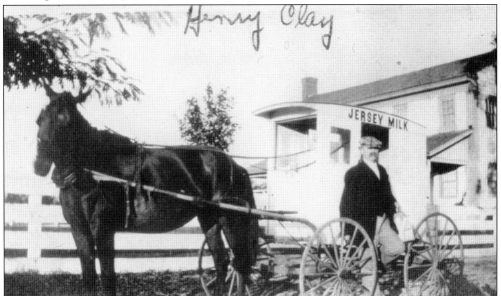

Milk that wasn't placed in cans for export to Philadelphia was strained again into bottles and delivered to residences throughout Snow Hill by a horse-drawn milk cart like the one shown in the picture above. The photograph has "Henry Clay" handwritten on it, but the photograph's source states the person in the photograph is Otis Northam. (Courtesy of Worcester County Library. Source: Elsie Northam.)

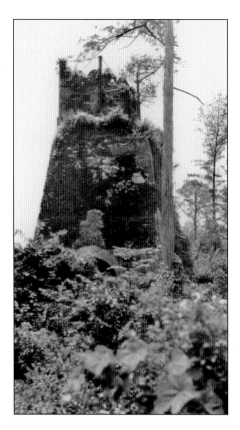

The Nassawango Iron Furnace, pictured covered with overgrowth, was built in 1829 near Snow Hill and operated through 1850. It was situated on 5,000 acres of forest and swamp, and it produced "pig iron," which was a raw material used to make steel. (Courtesy of the Julia A. Purnell Museum: the Frances Sturgis Collection.)

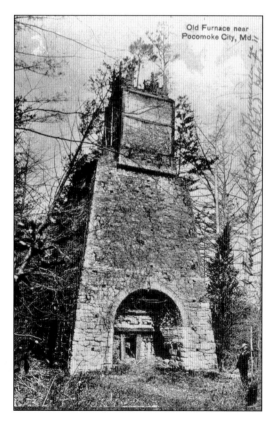

Bog iron was gathered from the nearby swamps and smelted in the furnace to make pig iron bars, which were put on barges and shipped down Nassawango Creek, down the Pocomoke, and then on to larger cities such as Baltimore or Philadelphia. (Courtesy of Worcester County Library.)

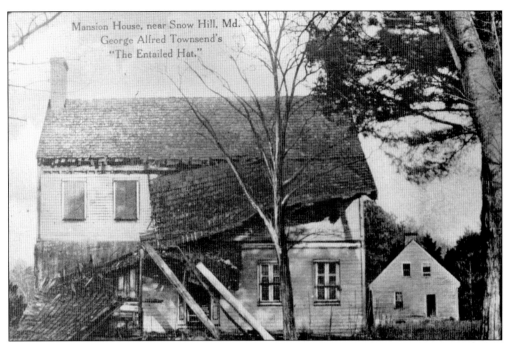

The area around the iron furnace was dubbed "Furnace Town" and grew to a population of over 400 with a post office, sawmill, stores, gristmill, and workers' houses. Shown here is the iron master's house, built around 1830. This 1910 photograph shows it in disrepair. (Courtesy of Worcester County Library.)

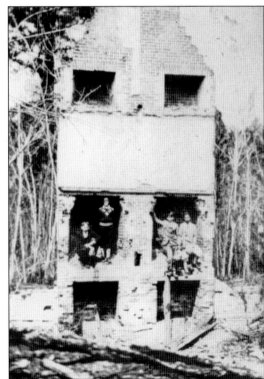

The days when Furnace Town was a thriving village have been immortalized in George A. Townsend's novel *The Entailed Hat*. Shown is the side view of the old mansion house remains at Furnace Town. (Courtesy of Worcester County Library. Source: Vic Dickerson.)

There was a great fire in Snow Hill in 1893, and most of the downtown district and the courthouse were destroyed. The entire town was rebuilt with brick commercial buildings; many buildings had ornate cornices at the top, as seen in this photograph of Green Street looking east. The brick structures were modern looking for the time and resistant to fire. (Courtesy of Janet Carter.)

This view of Green Street's north side shows early automobiles and an advertising sign for Collins Men's Store that reads, "Dry Goods, Notions, Shoes, Hats, Trunks—Bags, Dress Suit Cases—Gents Furnishings, Men's Taylor Made Clothing." (Courtesy of Janet Carter.)

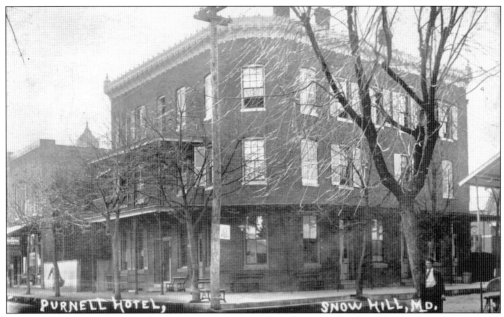

At the corner of Green and Washington Streets, shortly after the fire of 1893, a new hotel was erected by M. T. Purnell. Called the Purnell Hotel, this structure was designed by the same architect as the courthouse and the Governor's Mansion, Jackson C. Gott. It had a rounded front corner, metal cornices, iron galleries (porches), and modern conveniences. The hotel has since been torn down. (Courtesy of Janet Carter.)

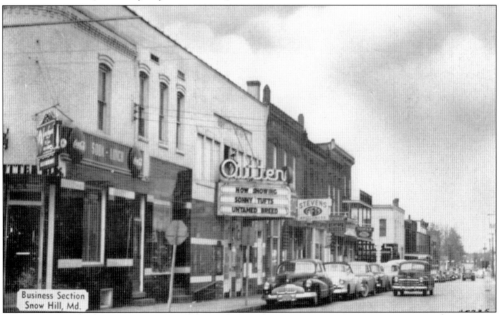

This shot of Washington Street in 1948 shows that Mason's Opera House had been converted to the Outten Movie Theater. The marquee shows the movie playing in the theater is *The Untamed Breed*, a Western. The corner building on the left has "Outten Building" written over the doorway, and the Purnell Hotel is still visible at the opposite corner. All parking spaces are filled. (Courtesy of Janet Carter.)

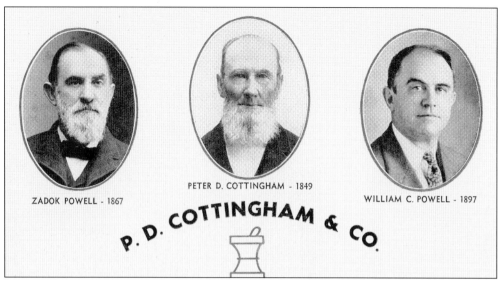

Peter D. Cottingham, pictured in the center of this calendar advertisement, was born in Worcester County in 1821 and lived most of his life in Snow Hill, where he raised his family of two daughters. He became a pharmacist and opened P. D. Cottingham Company in 1849. The store was later taken over by Zadok Powell and his son, William, also pictured on this advertisement. (Courtesy of Kenneth "Bert" Gibbons.)

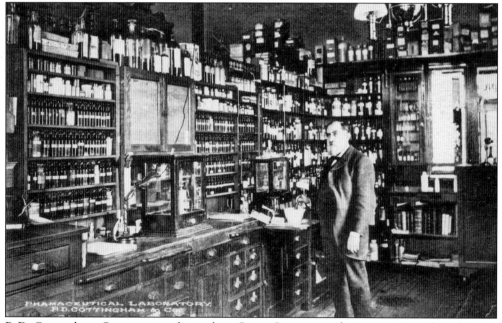

P. D. Cottingham Company was located on Green Street near the intersection of Pearl Street where the Snow Hill Business Center is today. Zadok Powell, who succeeded Peter Cottingham as pharmacist, is shown in this photograph postcard mixing some of his famous "elixirs" in his pharmaceutical laboratory.

Stanford's Butcher Shop hung butchered hogs in front of the store from the overhang. Owner Tom Stanford (pictured in the doorway) was known for giving excellent service and providing some of the best scrapple, bacon, and pork products in the region. His store was located on the west side of Washington Street just north of Green Street. (Courtesy of Randall and Joanne Mariner.)

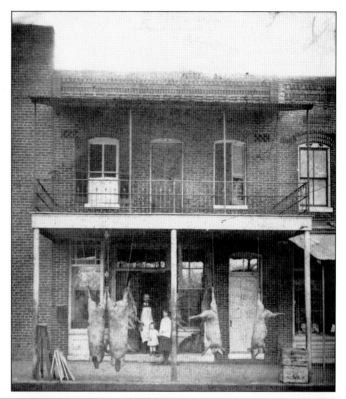

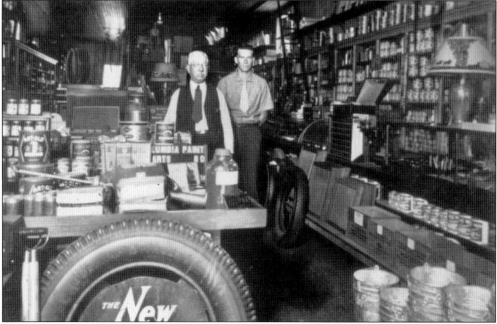

Turner's Hardware Store was also located on the Washington Street block between Green Street and the river. However, it stood on the east side near the block building that is adjacent to the present-day post office. Shown in the photograph are owner Walter Turner (dark tie) and Lester Taylor, an employee. (Courtesy of Worcester County Library. Source: Elsie Northam.)

Machree Allender Corddry, wife of Charles Corddry Sr., is pictured here in 1914 dressed beautifully complete with hat. Her husband, who was vice president of the Corddry Company, had just been elected mayor of Snow Hill when the photograph was taken. (Courtesy of Rosemary Corddry Manning.)

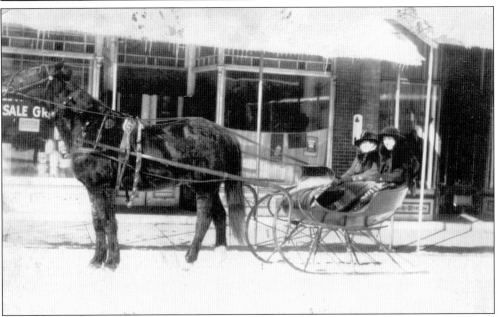

Lottie Fooks, pictured here in a horse-drawn sleigh with her friend, Frank Shockley (a female), owned a millinery on Green Street, which is now where Western Auto is located. Fooks had a three-legged dog named Spottie, which led to the common phrase uttered by locals who saw her approaching, "here comes Lottie with her dog, Spottie." Frank Shockley was a seamstress in town. (Courtesy of the Julia A. Purnell Museum: Frances Sturgis Collection.)

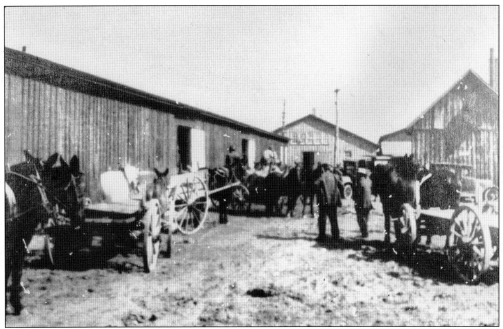

Worcester Fertilizer was incorporated in 1913 and located on the east bank of the Pocomoke River. This location provided a perfect opportunity to have raw materials needed to manufacture the fertilizer shipped in. Originally farmers would bring their wagons to the company's location and load the fertilizer, as shown in this photograph. Eventually the company shipped product out by rail, water, and trucks. (Courtesy of Worcester County Library. Source: Sara Barnes Davis.)

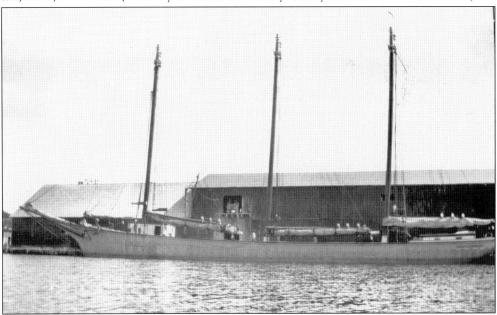

The *Edward R. Baird Jr.* was a three-masted schooner, much like the one pictured here, built in 1903. Worcester Fertilizer purchased her in 1946 and used her for hauling raw materials in and shipping fertilizer out between Baltimore and Snow Hill. Her master was Capt. Ray Brewington, who lived in Snow Hill. (Courtesy of the Julia A. Purnell Museum: the Frances Sturgis Collection.)

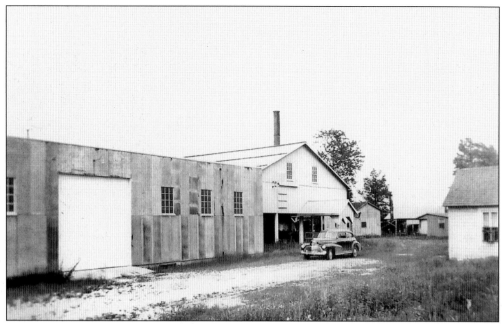

From 1890 through 1960, canneries were a major business in Snow Hill. Shown here is a photograph of the Wesley Canning Company, which was located on Cedar Town Road at the railroad crossing, which was subsequently named Wesley Station after the cannery. The cannery, which canned tomatoes, was owned by W. T. Onley and Kelly Berdan. It closed in the 1950s. (Courtesy of Huey Brown.)

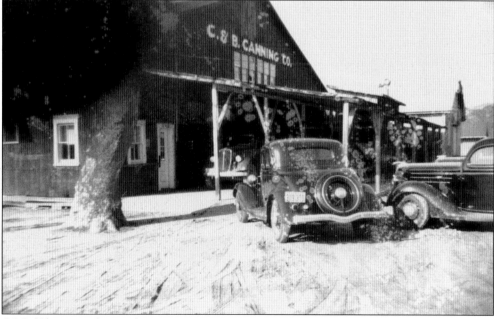

C&B (Cherrix and Brown) Canning Company was founded in 1936 but became Brown Canning Company shortly thereafter. The company began canning peas, lima beans, green beans, and tomatoes, and it eventually became one of the three large canneries in Snow Hill that employed large numbers and contributed much to the local economy. (Courtesy of Huey Brown.)

Ralph S. Brown was the founder of Brown Canning Company, which operated near where Worcester County Fertilizer was located on the river. Brown led the company to success, which lasted over 30 years and at its peak was producing 125,000 cases of tomatoes and green beans each year and employing as many as 100 people in canning season. (Courtesy of Huey Brown.)

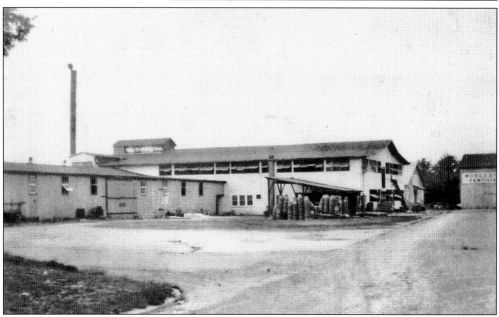

Brown Canning Company, shown around 1946, was one of four canning companies in Snow Hill that not only employed hundreds of people but were directly responsible for processing crops farmed on thousands of acres of land planted in the surrounding areas. At peak performance, these canning companies were processing an estimated 1.5 million baskets of tomatoes per season, in addition to other produce. (Courtesy of Huey Brown.)

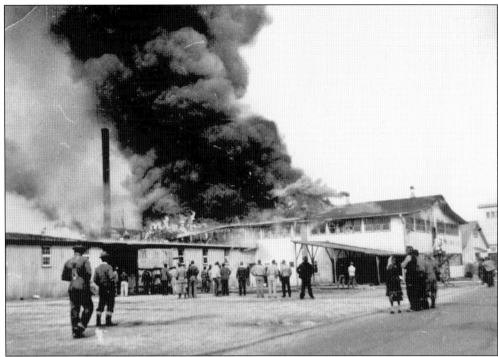

In 1950, the Brown Canning Company suffered major fire damage and its location near the river was virtually destroyed, resulting in a loss of over $100,000 to the company. Ralph Brown and his sons quickly reopened the company in a new location at the Spector Mill basket factory across town, which was in close proximity to the railroad station. (Courtesy of Huey Brown.)

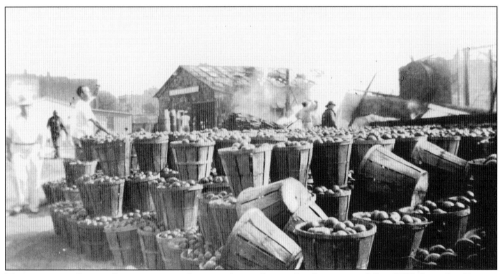

Tomatoes smoking after a cannery fire are shown here. At the time of the 1950 fire, the Brown Canning Company was employing 400 to 500 people in peak season. The Snow Hill business community hailed the quick relocation and reopening of the company as an "achievement in progress" because it kept many employed. (Courtesy of Huey Brown.)

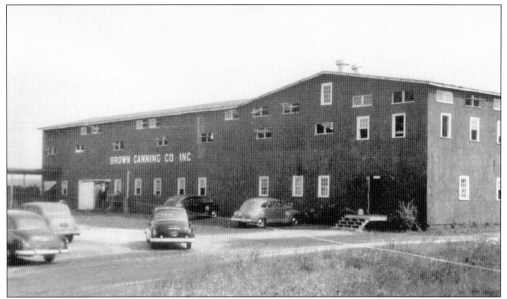

The Brown Canning Company, pictured, rebuilt a facility in its new location after the fire. The *Democratic Messenger* headlines printed accolades to the company for reopening so quickly, such as "Ralph S. Brown and his two sons carrying on the spirit of progress" and "[reopening quickly] reflects the loyalty of its owners to the community and their faith in its people." (Courtesy of Huey Brown.)

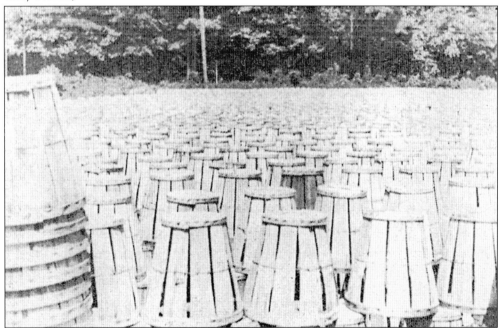

The baskets shown in this photograph were set out to dry in the sun before being sent out to farmers to be filled with tomatoes and then sent to local canneries in Snow Hill. These baskets were manufactured in Snow Hill at a factory along the railroad. The factory made baskets and butter dishes. Brown Canning Company replaced the basket factory in its location there in 1954. (Courtesy of Huey Brown.)

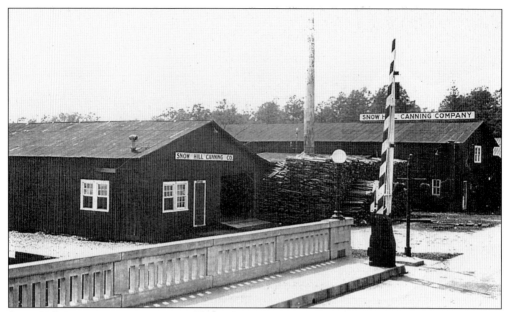

Snow Hill Canning Company, started by Paul G. Wimbrow before World War I, was located on the north side of the Pocomoke River Bridge and was another of the big canning companies in Snow Hill. The wooden structure shown here was purchased by Wimbrow in 1936. A fire in 1944 completely destroyed the facility during the height of World War II. (Courtesy of Mary Wimbrow.)

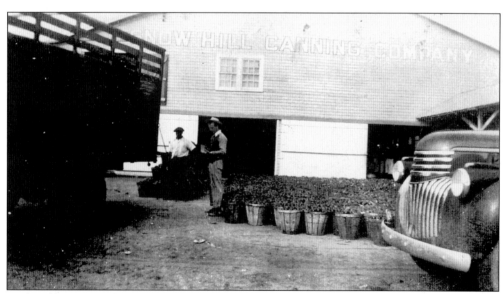

Paul and his son, Jack Wimbrow, rebuilt the canning company during the winter of 1946–1947 once Jack returned home from the Marine Corps at the end of the war. This photograph shows the new plant that Reese Scott, a contractor, and Jack built with cinder blocks in 1947. (Courtesy of Mary Wimbrow.)

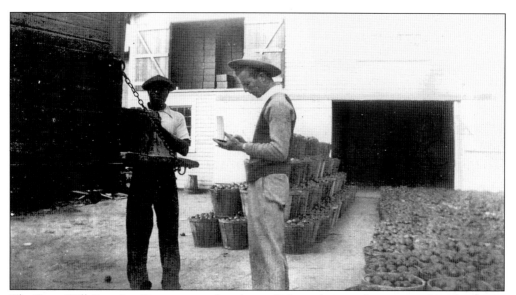

The Snow Hill Canning Company employed over 500 people in peak season at three locations. The Snow Hill plant alone used 150,000 baskets of tomatoes in one season. Three hundred acres of tomatoes were grown on local farms to supply Snow Hill Canning Company. Jack Wimbrow is shown here writing a ticket of basket count to a grower. Growers were paid by the basket. (Courtesy of Mary Wimbrow.)

The building that Jack built in the late 1940s still stands today and has housed several businesses recently. Shown is Jack Wimbrow with his two children, Lois (left, 2 years) and Jimmy (3 years), in front of the cannery in 1952. The other child is an unidentified friend of the Wimbrow children. (Courtesy of Mary Wimbrow.)

Levi Truitt is shown here in 1934 with his automobile. Truitt worked for Worcester County Fertilizer for many years and then became a waterman and had an oyster bar near the community of Box Iron outside of town. Snow Hill citizen Becky Payne Laws, daughter of Gus Payne, remembers learning how to eat her first clam at Levi Truitt's oyster bar. (Courtesy of Ann Coates: the Frances Sturgis Collection.)

This photograph had "C. V. White's gadget" written as a caption underneath. No one can identify what the gadget was for, but many remember town resident C. V. "Corrie" White was a prominent businessman and part owner and founder of the *Democratic Messenger*, which became an influential county newspaper. (Courtesy of Ann Coates: the Frances Sturgis Collection.)

Four

THE GREAT
POCOMOKE RIVER

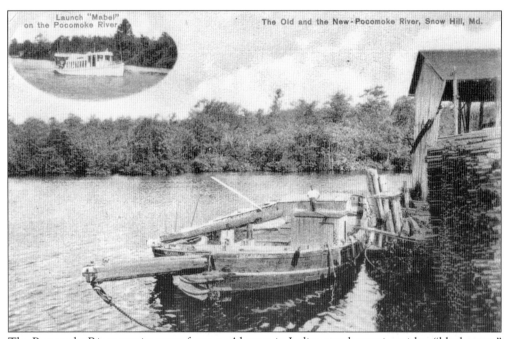

The Pocomoke River gets its name from an Algonquin Indian word meaning either "black water" or "abounding in fish." Either would make sense as the river's dark, coffee color and swampy atmosphere are due to seepage from the abundance of cypress and pine trees along the river's edge. The Pocomoke is about 73 miles long, stretching from southern Delaware to the Pocomoke Sound in Crisfield, Maryland, with its headwaters of navigation being in Snow Hill. The river and its banks are scenic and rich in wildlife, offering habitats to muskrats, weasels, otter, turtles, deer, raccoons, opossums, grey squirrels, and flying squirrels. Additionally there are bald eagles, hawks, owls, peacocks, kingfishers, woodpeckers, and vireos. This scenic quality offers recreation, but the river has been a determining factor in Snow Hill's prosperity, being the avenue of trade imports and exports for nearly 300 years. Up through the 1960s, schooners, steamers, and power boats have been plying the waters of the Pocomoke, bringing raw materials, exported goods, passengers, and the news of the day to and from Baltimore, Philadelphia, and beyond. (Courtesy of Janet Carter.)

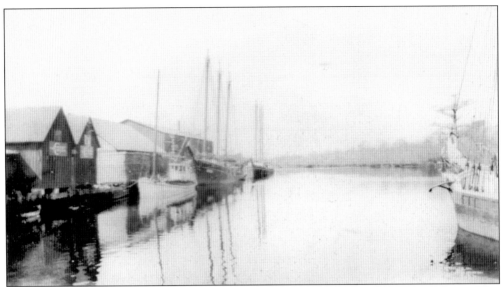

Here various boats are lined up along Corddry Company and Worcester Fertilizer Company. This photograph was taken at a time when shipping traffic up and down the stretch of the Pocomoke River to the Chesapeake Bay was a key in trade success. Raw materials were shipped in, and goods to export to other markets were shipped out. (Courtesy of the Julia A. Purnell Museum: the Frances Sturgis Collection.)

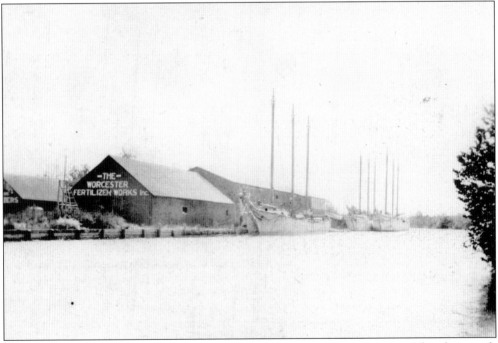

Shown here are three-masted schooners operated by Worcester Fertilizer Company. This photograph was taken in the early 1930s and depicts a scene common to the Pocomoke River in town. Worcester Fertilizer was dependent upon the use of schooners to sail in from Baltimore with the raw materials they used to make their fertilizer, which was used by farmers in six counties. (Courtesy of the Julia A. Purnell Museum: the Frances Sturgis Collection.)

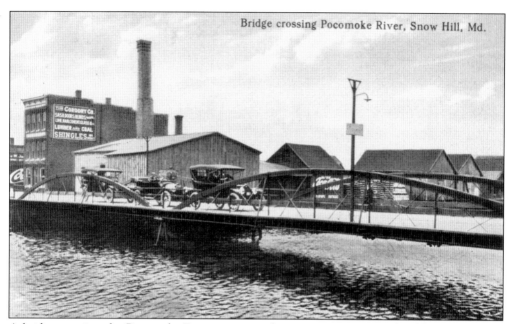

A bridge crossing the Pocomoke River was crucial to commerce as it tied industry located on both sides of the river with the town. This bridge was stationary and thus marked the headwaters of navigation for the Pocomoke. Shown in this postcard is a 1930s scene of the Pocomoke River Bridge with cars crossing and the Corddry Company hardware store on the far left. (Courtesy of Janet Carter.)

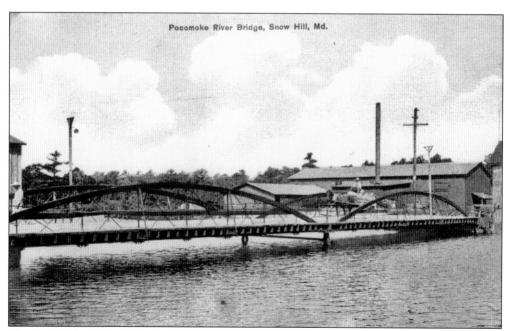

The Pocomoke River Bridge in Snow Hill also linked farmers north of town and traffic from the village at Furnace Town with Snow Hill. Shown here is an early-20th-century photograph of the bridge with a horse and cart traveling into town. (Courtesy of Janet Carter.)

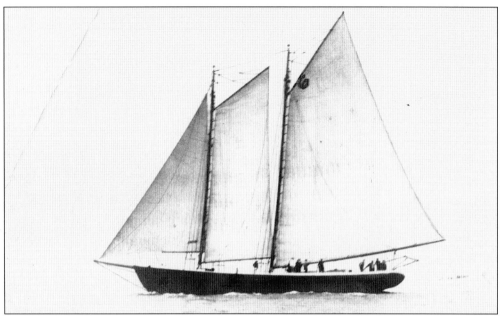

This two-masted ram schooner known as *The Minie* was owned by Frank Scarborough of Girdletree and operated by an African American named Henry Chapman from Stockton. Most of the local schooner fleet was destroyed in the storm of 1933, but Captain Chapman, knowing a bad storm was approaching, risked his life and took the boat out to sea to ride out the storm. The schooner and the captain survived. (Courtesy of Huey Brown.)

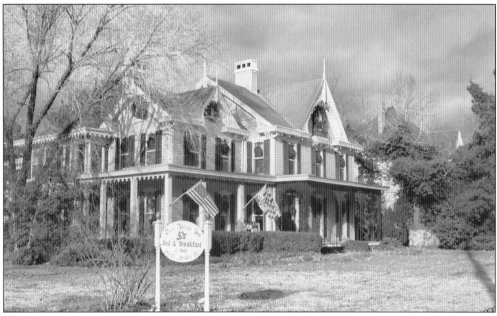

There are several stately houses that appear either on or near the shore of the Pocomoke River. The George Washington Purnell House, built in 1860 as a private home, is bordered by Market Street in the center of town and the Pocomoke River. Purnell was an attorney who had an office adjacent to the house on Washington and Green Streets. In recent years, the house has been converted from a private residence to the River House Inn Bed and Breakfast.

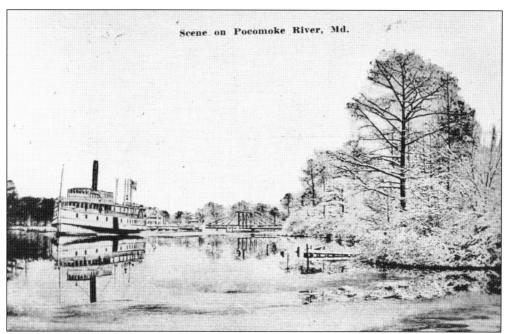

Steamboats on the Pocomoke River, like the one pictured in this postcard, cut transportation time from Snow Hill to Baltimore from two weeks to 39 hours. Steamers made it possible for passengers to travel back and forth to Pocomoke, Baltimore, and Philadelphia with relative ease. There was much romance associated with the steamers as well as the river. Town folk would go down to the wharf just to eye the steamers as they came in. (Courtesy of Worcester County Library.)

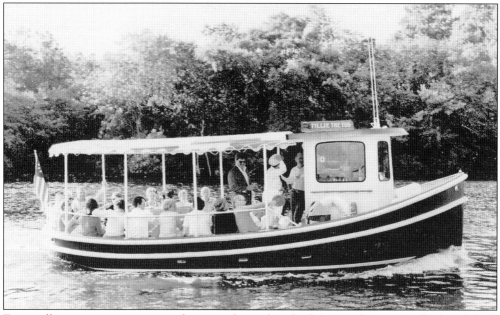

Eventually steamers gave way to other powerboats, but the ferrying of passengers back and forth continued. Pictured in this 1970s postcard is *Tillie the Tug*, a 22-foot passenger vessel with on-board narration about the Pocomoke River, its wildlife, and vegetation. (Courtesy of Kenneth "Bert" Gibbons.)

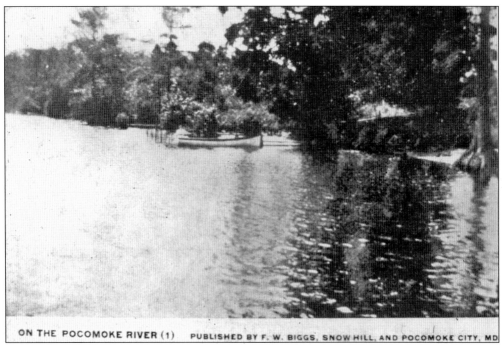

ON THE POCOMOKE RIVER (1) PUBLISHED BY F. W. BIGGS, SNOW HILL, AND POCOMOKE CITY, MD

This early shot of the Pocomoke River shows the roots of bald cypress along the tree-lined, rugged shoreline—common for the Pocomoke. In the distance is a canoe tied at a simple dock with the caption on the card reading "On the Pocomoke River." The card, published by W. Biggs of Snow Hill and Pocomoke City, illustrates the romantic sentiment of the day about the Pocomoke River. (Courtesy of Worcester County Library.)

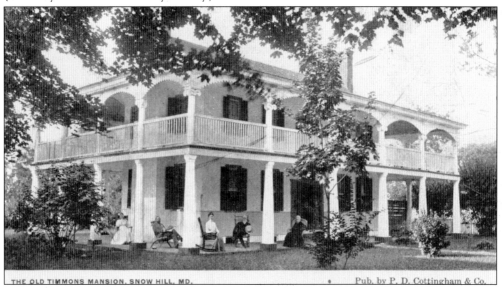

THE OLD TIMMONS MANSION, SNOW HILL, MD. Pub. by P. D. Cottingham & Co.

Another stately home near the Pocomoke River was the Timmons Mansion, built on this site around 1835. It is named for Capt. William E. Timmons, who lived there from when he purchased the home in 1856 until his death in 1902. Timmons served as clerk of the court in 1860, operated a trade vessel, and later supervised a warehouse on the river. This home was destroyed by fire in 1910. (Courtesy of Janet Carter.)

The river was also a favorite spot for recreation as illustrated in this photograph of Colbourne Littleton (left) of Pocomoke City and Charles W. Corddry Jr. of Snow Hill. It was taken by Charles's mother around 1928. She wrote on the photograph referring to son Charles, "My first 'dip.' My first picture with my hair cut like a 'boy.'" (Courtesy of Rosemary Corddry Manning.)

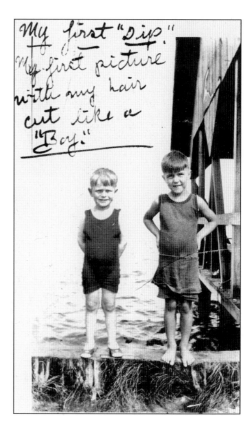

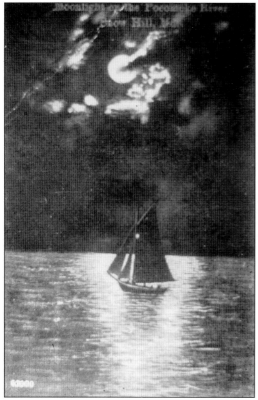

The visitor who mailed this 1920s postcard with the caption "Moonlight on the Pocomoke River—Snow Hill, MD" indicates that the Pocomoke River was a tourist draw for the town and was associated with scenic beauty and romance. (Courtesy of Worcester County Library.)

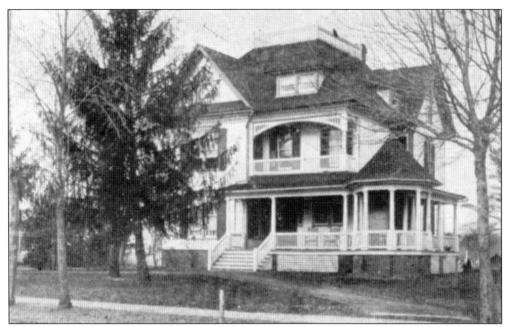

Dr. John L. Riley's house, also known as the Collins-Vincent House, is located at 210 West Market Street on the Pocomoke River, directly next to the Julia A. Purnell Museum. Riley, a well-loved Snow Hill doctor, occupied this exquisite example of Victorian Queen Anne–style architecture. His daughter, Virginia, owned the house until its sale in 2002 to its current owners. (Courtesy of Ellen Pusey, Ph.D. collection.)

SCENE AROUND SNOW HILL, MD.

This image of the unhardened shoreline of the Pocomoke River was taken from behind Dr. Riley's house and shows an eastern viewpoint looking toward the Pocomoke River Bridge. Corddry Company can be seen as can one of the spires of Makemie Presbyterian Church. (Courtesy of Janet Carter.)

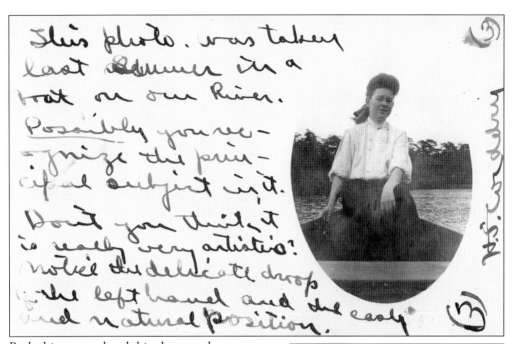

This photo. was taken last summer in a boat on our River. Possibly you rec-ognize the prin-cipal subject in it. Don't you think it is really very artistic? notice the delicate droop of the left hand and the easy and natural position.

(3)

H.S. Corddry

Both this postcard and this photograph were purchased at the estate auction of Dr. John Riley's daughter, Virginia Riley Crocker. The man in the 1930s photograph is George Corddry Jr., a Snow Hill schoolteacher who courted Virginia Riley. He is seated on a porch at the Riley home. The woman pictured on the postcard is possibly Virginia's mother, Beulah Vincent Riley. The note on the postcard was written by Harris Stagg Corddry (son of William D. Corddry Jr.) to the woman pictured. It reads, "This photograph was taken last summer in a boat on our river. Possibly you recognize the principal subject in it. Don't you think it is very artistic? Notice the delicate droop of the left hand and the easy and natural position. [signed] H. S. Corddry." Harris Corddry, born in 1888, became a prominent member of the community and served as secretary/treasurer of the Corddry Company. He married Emily Stevenson in 1935 (his second wife). They had one child named Riley Stevenson Corddry. (Courtesy of John Layo.)

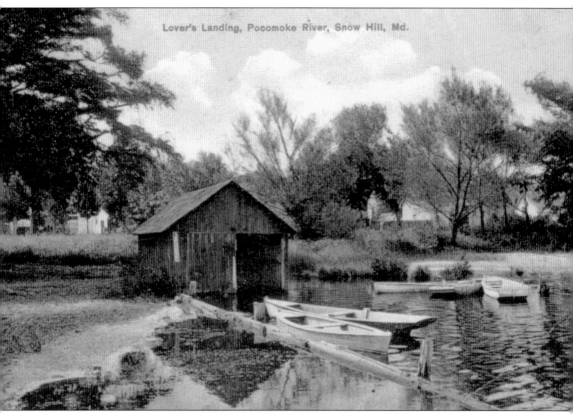

Lover's Landing, Pocomoke River, Snow Hill, Md.

This postcard image entitled "Lover's Landing" shows not only the scenic character of the Pocomoke River, but the romantic sentiment attached to the river by the people of Snow Hill. Few people living can remember Lover's Landing or where it was exactly, but most can recall secret meeting places for young lovers. (Courtesy of Janet Carter.)

Five

FAITH, EDUCATION, AND FUN

Snow Hill's history, like most towns, is chronicled in memories of special events, faith communities, and growing up. Churches abound and dot the streetscape, including one occupied by the oldest Presbyterian congregation in America. Schools were always present in the last two centuries and showed continued growth and improvement. This photograph shows a primary school class dressed in costume for a play put on in 1936. The only child identified is Laura Gordy Adkins, second row, third from the left. Special events such as Memorial Day parades, field days, baseball games, graduations, or nights out on the town reveal the town's enthusiasm for celebration and a strong community foundation. Harness races were held off Bay Street, and a semi-pro baseball team was established in 1924. The Memorial Day parade photographs in this chapter were taken in 1934 by Jim Sturgis, businessman and former mayor of Snow Hill, and depict Snow Hill's zest for patriotism and celebration. (Courtesy of the Julia A. Purnell Museum: the Frances Sturgis Collection.)

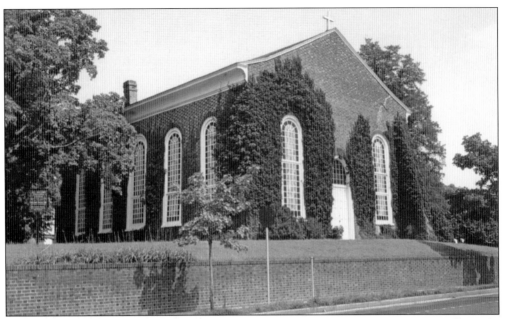

All Hallows Protestant Episcopal parish in Snow Hill was founded in 1692 as Snow Hill Parish. The original church building was located between the present building and the river, and by 1711, the name of the parish was changed to All Hallows. The present church building shown in this photograph was built around 1756. It is said that some of the ivy that grows up the sides of the church was brought from Kenilworth Castle in England. (Courtesy of the Julia A. Purnell Museum.)

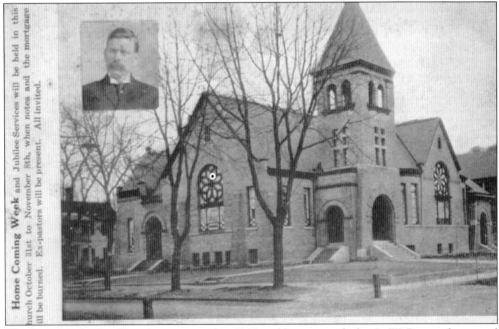

The Bates Methodist Church was erected in 1901 and later named after L. W. Bates, who served as minister in 1844. The present church building, which dominates the corner of Market and Washington Streets, was rebuilt in 1947 under Rev. Elmer Shield. In the photograph, former pastor L. A. Bennett is pictured on the inset. (Courtesy of the Julia A. Purnell Museum.)

Makemie Memorial Presbyterian Church at Snow Hill was founded by Francis Makemie in 1683, making it the first established Presbyterian community in America. The present church building, with its dramatic Gothic spires that dominate the Snow Hill skyline, was begun in 1887 and dedicated on June 28, 1890. (Courtesy of Worcester County Library.)

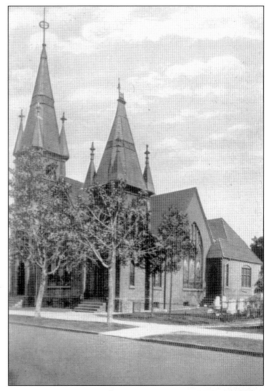

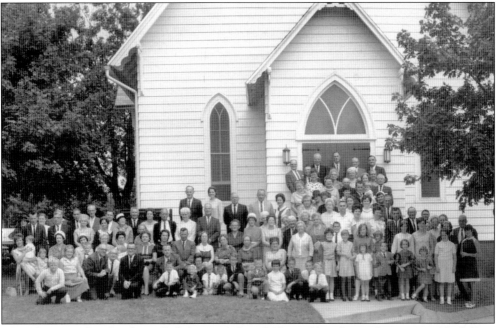

The Christian church, also called the Disciples of Christ Church, on the corner of Park Row and Bay Street was organized in 1897, and the present building was completed and dedicated in August 1899. Shown here are members of the congregation who came to celebrate the 70th anniversary of the church. (Courtesy of Janet Carter.)

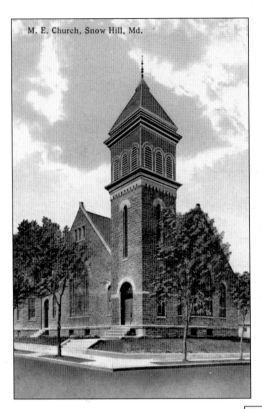

M. E. Church, Snow Hill, Md.

Whatcoat Methodist Church, which is located on the corner of Federal and Washington Streets, was erected around 1900. There were three previous church buildings in another location. The church was named for Rev. Richard Whatcoat, who was a bishop in the area.

The original Whatcoat Methodist Church was built on what is presently the cemetery on land bought from James Martin for $45. This church, erected in 1856, was distinctly modern and replaced two previous church buildings. It served the community until 1900 when the present church was erected. The original Whatcoat Church in this photograph was razed in 1902. (Courtesy of Anne Kinstler.)

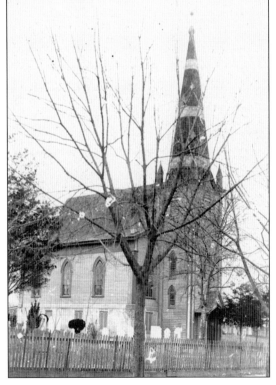

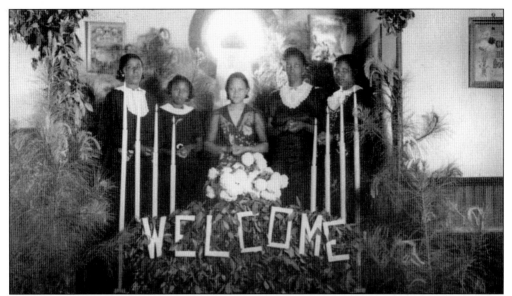

This photograph shows five female members of the Ebenezer United Methodist Church behind a welcome display. The writing on the photograph said "Ebenezer Homecoming." This church was established in 1869 and has historically served the African American community in Snow Hill. The present church building was erected in 1899 and is located on Collins Street across from the Whatcoat cemetery. (Courtesy of the Julia A. Purnell Museum.)

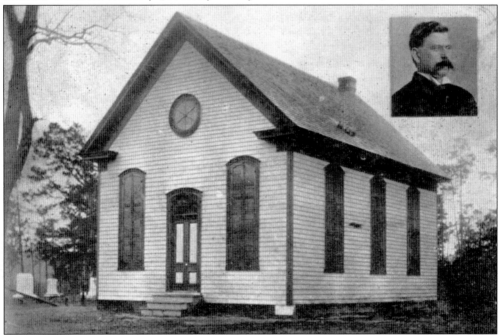

The Nassawango Methodist Protestant Church was organized in April 1882. The church building, seen with Pastor L. A. Bennett pictured on the inset (the same pastor pictured on the inset of Bates Methodist Church on page 70), was located on the Amos Pennewell property near Furnace Town. Snow Hill mayor Frank Fooks and his family were longtime members of this church. (Courtesy of Janet Carter.)

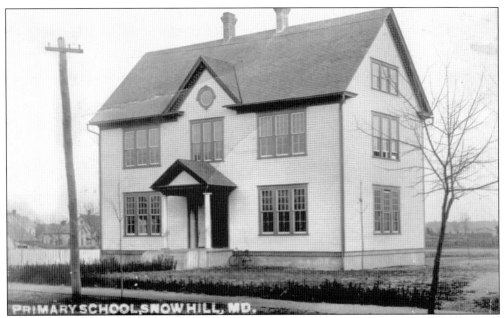

The Snow Hill Primary School (grades one through four) was located at 202 East Federal Street. It was opened in 1912, and the schoolyard ran from Federal Street to Martin Street. The building has since been demolished, and the lot where it once stood is now vacant and owned by Whatcoat Methodist Church as a lot for expanding their cemetery. (Courtesy of Janet Carter.)

The Mount Zion one-room schoolhouse was built in 1869 and located near the village of Whiton. It housed seven grades in one large room and closed in 1931 when Snow Hill's first high school was built. It is now located adjacent to the old high school and operates as a museum under the direction of the Worcester County Retired Teachers Association. (Courtesy of Worcester County Library.)

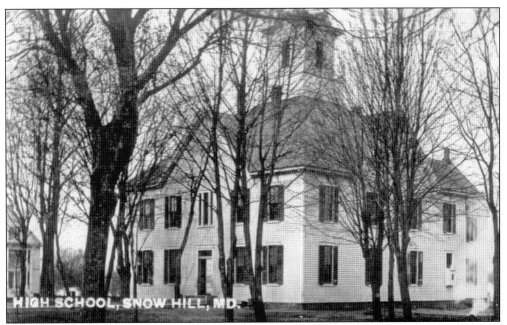

The old Snow Hill High School was a two-story, wooden-frame building with a bell tower on top. It was located on the corner of Federal and Morris Streets. The bell was rung with a pull rope to identify the beginning of school sessions or periods. It remained in use until the 1930s, when a larger, newer high school was built. (Courtesy of Janet Carter.)

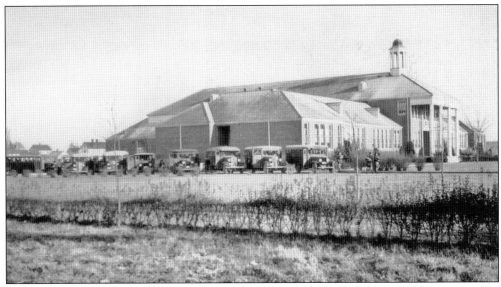

Snow Hill opened a new high school on Church Street around 1938. Here is a photograph taken shortly after it opened. Notice the early model school buses parked in the lot. Students were bussed in from neighboring farm communities including Stockton, Newark, and Girdletree. The building has been converted to a senior services facility. (Courtesy of Ann Coates: the Frances Sturgis Collection.)

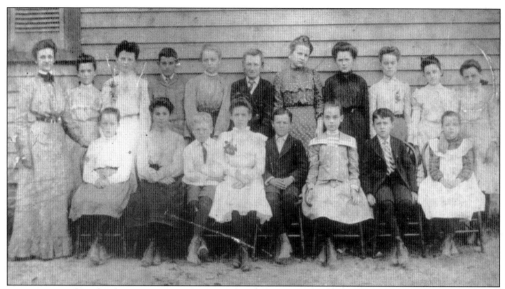

The Snow Hill High School class and teachers of 1909 are shown here in front of the old high school building. From left to right are (seated) Fannie Nelson Truitt, Eva Godfrey Hearthway, Irl C. Riggin, Carolyn Hargis, Lora Bailey, Jessie Townsend, G. Ewell Dryden, and Pearl Layton Pruitt; (standing) Mrs. Lida E. Clayville Turner (teacher), Mary Hearn, Violet Taylor, Lawrence Godfrey, Irene Mason, Walter Collins, Mary Emily Dryden, Pearl Campbell, Edna Hill, Mary Lee Truitt, and Georgie Dorman. The photograph was taken in 1903. (Courtesy of Worcester County Library. Source: Rodney Bounds.)

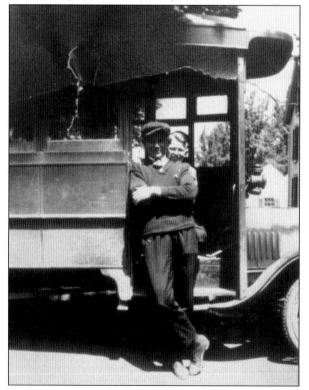

Harvey Pusey was the first school bus driver in Worcester County. Pusey is shown in this photograph leaning against the bus door with one curious little student peeking over his left shoulder. (Courtesy of Worcester County Library. Source: Paul Joyner.)

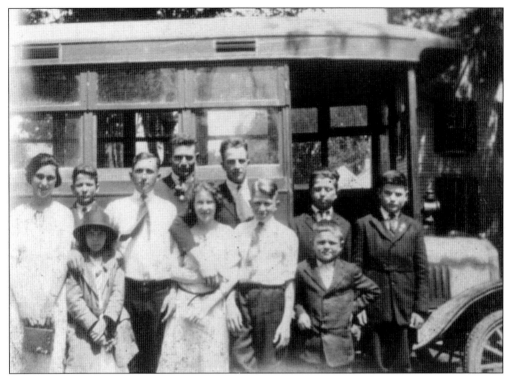

Shown in this photograph are the students from Harvey Pusey's bus. Notice how the boys wore suits and the girls wore dresses. Harvey, the driver, is fourth from the left standing in the rear. The others in the photograph could not be identified. (Courtesy of Worcester County Library. Source: Paul Joyner.)

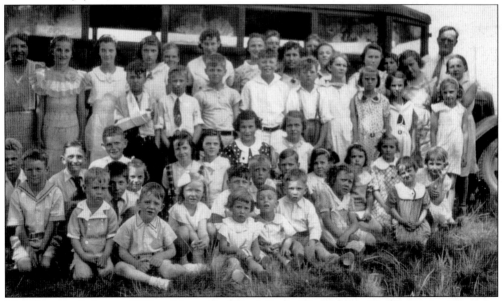

This photograph dates to 1936 and shows the "Gordy Bus" with the driver, Mr. Gordy, standing at the far right and an adult woman (presumably a teacher) on the far left. Between them are 48 students of all grades. (Courtesy of the Julia A. Purnell Museum: the Frances Sturgis Collection.)

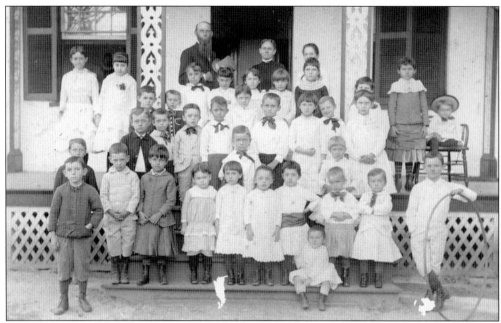

A private day school operated out of a back room upstairs in Chanceford Hall on Federal Street in the early 20th century. It was run by Nan Stevenson. Education was practical at "Miss Nan's" school and included not only academic subjects but also daily tasks, such as how to place a phone call or how to order merchandise to be delivered from local stores. One of Stevenson's classes is pictured here at Chanceford. (Courtesy of Randall and Joanne Mariner.)

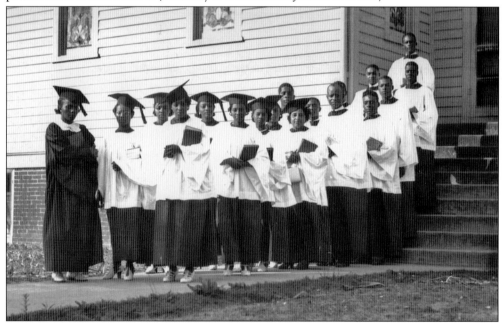

The 17 graduates and one teacher pictured here in front of Ebenezer Methodist Church on Collins Street could not be identified. This photograph was mixed in with others at the Julia A. Purnell Museum with the inscription on the back of the photograph reading "Graduation at Ebenezer Methodist Church." No date was given. (Courtesy of the Julia A. Purnell Museum.)

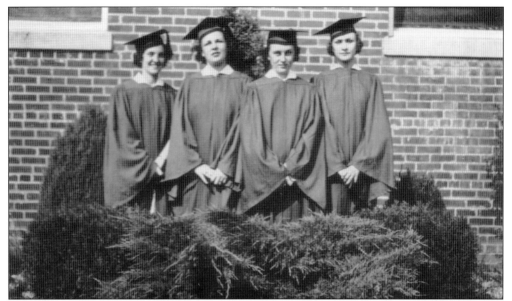

Virginia Sturgis, who was a member of the Snow Hill High School graduating class of 1936, identified these classmates posed in front of the high school in caps and gowns. From left to right are Mabel Perdue (daughter of J. H. Perdue), Mary Jane Purnell (who later married a Fullington), Kathryn Truitt (who married a Calhoun), and Frances Scarborough Sturgis. (Courtesy of the Julia A. Purnell Museum; the Frances Sturgis Collection.)

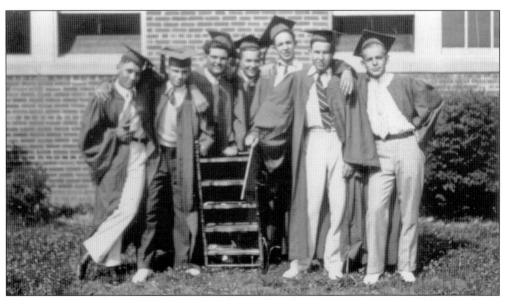

Sturgis also identified these young men who graduated in 1936 from Snow Hill High School. From left to right are Raymond Lank, Carlton Connor, Charles Tully, Harry McCann, Tom Sturgis, Linwood Parson, and Bill Cherrix. (Courtesy of the Julia A. Purnell Museum: the Frances Sturgis Collection.)

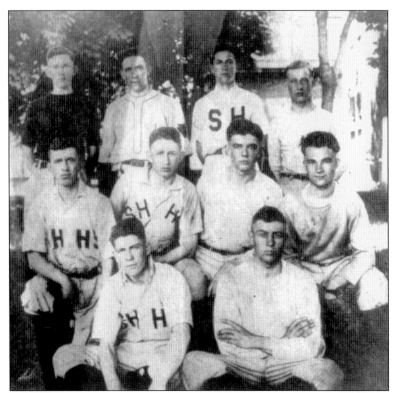

Baseball was competitive and popular at Snow Hill High School. This photograph taken by Will Hearn shows the baseball team of 1917–1918. From left to right are (first row) Edward White and Victor Keene; (second row) Frank Sturgis, Dorsey Stougis, George Truitt, and Ralph (Ted) Purnell; (third row) Straughn Sturgis, George Mumford, William Hickman, and Robert Emery. (Courtesy of Worcester County Library. Source: Dorothy Taylor.)

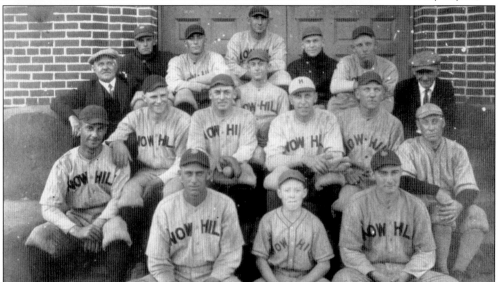

Shown here is the Snow Hill semi-professional ball team of 1921. From left to right are (first row) Cutter Drury, center field; Sid Timmons, mascot; and Reds Kilduff, catcher; (second row) ? Sharretts, left field; unidentified; George Keen, first base; Herb Armstrong, second base and manager; Augie Schoroll, pitcher; and Charles Hudson, right field; (third row) Oscar Purnell, business manager; Bill Hickman, pitcher; and Jim Whaley, assistant business manager; (fourth row) ? Gladmann, pitcher; unidentified; Ike Rousey, shortstop; Stanley Robins, third base; and Whitey Swingler, catcher. (Courtesy of Worcester County Library. Source: Elva Parks.)

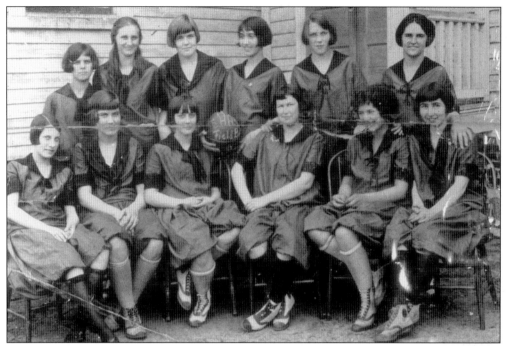

The undefeated county champion Snow Hill Field Ball Team is pictured here in 1924. From left to right are (seated) Edgeworth Humphreys, Mary Clarke, Elizabeth Dennis, Mabel Gordy, Neva West, and Virginia Taylor Johnson; (standing) Matt Henderson, Elizabeth Sturgis, Lola Dryden, Ruth Lynch, Ethel Scott, and Ella Gordy. (Courtesy of Worcester County Library. Source: Elva Parks.)

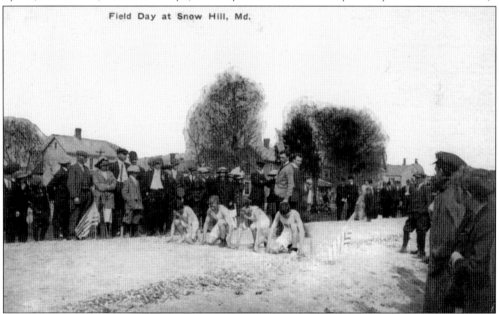

This photograph postcard with the title "Field Day at Snow Hill" recounts the once-a-year event where schools from all over the county came together to compete in various athletic events. Shown here are four boys with what looks like "SH" on their shirts getting ready for a race. (Courtesy of the Ellen Pusey, Ph.D. Collection.)

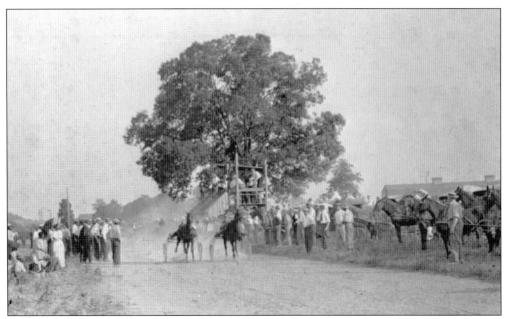

Snow Hill had its own horse racing venue off Bay Street. While some harness races actually occurred there for spectators, the track was primarily used for training horses that were raced in other areas, particularly the fairgrounds at Pocomoke City and Salisbury. This photograph dates to 1912. (Courtesy of Worcester County Library. Source: Tish Dryden.)

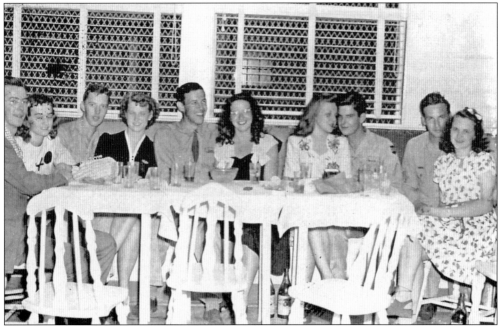

On leave from World War II in 1944 with their dates at the Pier Club are, from left to right, Gus Payne, Aline Mumford Payne, Henry Tilghman, Barb Morris, Huey Brown, Anna Lee Butler, Suzanne Clifton, Johnny Vincent, Fowler Cottingham, and Pauline Cottingham. Johnny and Fowler spent time in German POW camps. All of these men returned home, went to college on the GI Bill, and settled in Snow Hill. (Courtesy of Huey Brown.)

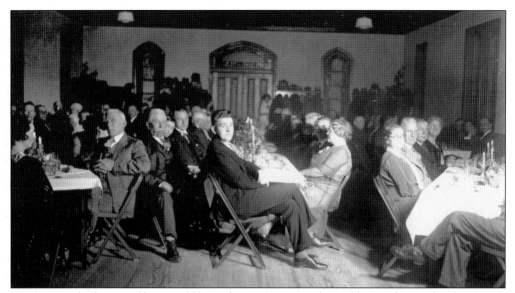

The banquet hall pictured here could be at the Bay View Hotel in Public Landing as the photograph was grouped with other Bay View photographs. This photograph was taken in 1934 of a formal dinner in Snow Hill with the caption "Holloway Banquet" written on the picture by Frances Sturgis. Charles Corddry is seated at the first table on the left. (Courtesy of Ann Coates: the Frances Sturgis Collection.)

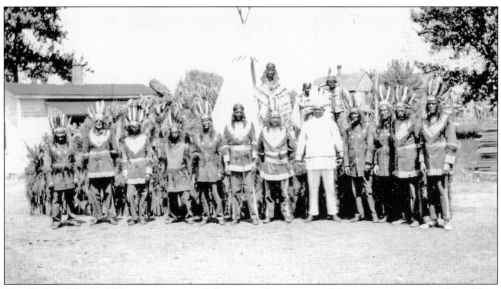

The Order of the Red Men was a national fraternity that promoted American patriotism, friendship, loyalty, and charity. Shown here is the Snow Hill fraternity in 1934. (Courtesy of Ann Coates: the Frances Sturgis Collection.)

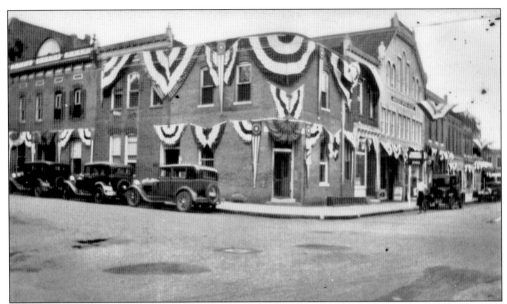

Memorial Day parades were popular in small towns across America especially between the world wars. The Memorial Day parade of 1932 shows Snow Hill buildings decked out in red, white, and blue as shown in this photograph of Market and Washington Streets. (Courtesy of Ann Coates: the Frances Sturgis Collection.)

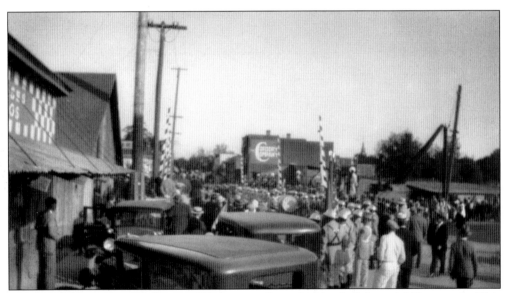

The crowds begin to gather here on Washington Street before the Memorial Day parade. This photograph was taken on the north side of the river looking in the direction of the courthouse. Most of the people in the photograph appear to be in the parade. The Corddry Company hardware store can be seen on the right. (Courtesy of the Julia A. Purnell Museum: the Frances Sturgis Collection.)

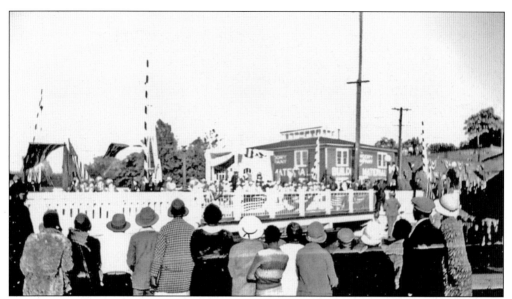

The Memorial Day parade of 1932 is processing across the Pocomoke River drawbridge. The onlookers are standing on the north side of the river near Snow Hill Canning Company. Corddry's warehouse—now the Pocomoke River Canoe Company—can be seen in the distance. (Courtesy of Ann Coates: the Frances Sturgis Collection.)

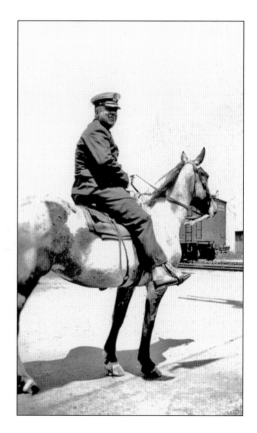

Randall Purnell, shown on his horse, worked as a policeman. He also owned a fish market in town on Commerce Street near where the library stands today. Purnell also drove the ambulance for the police department and had a taxi. (Courtesy of Ann Coates: the Frances Sturgis Collection.)

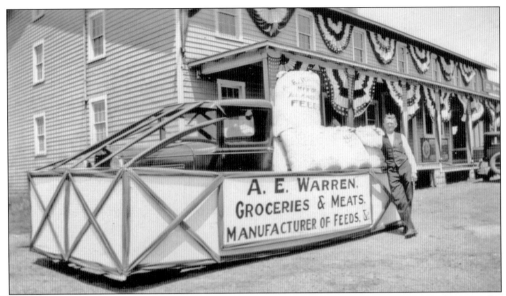

Stores would create floats with advertisements on them for the parades. Shown here is the float made for A. E. Warren, a grocery store with a meat counter located near the railroad tracks on Bay Street. A. E. Warren gave Bert Gibbons's mother a dollar when she gave birth to Bert in 1921 to start a savings account for her new baby. (Courtesy of Ann Coates: Frances Sturgis Collection.)

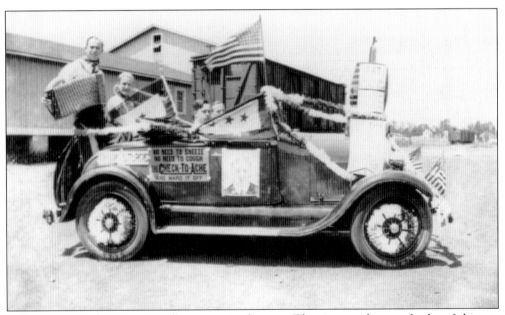

Riding in a parade was an excellent way to advertise. The sign on the rear fender of this car says "Frank Sturgis." Two people are riding in the rumble seat; the man playing an accordion is offering entertainment. The car also advertises a product that will prevent a cold by stating, "No need to sneeze, no need to cough, take Check-to-Ache and ward it off." (Courtesy of Ann Coates: the Frances Sturgis Collection.)

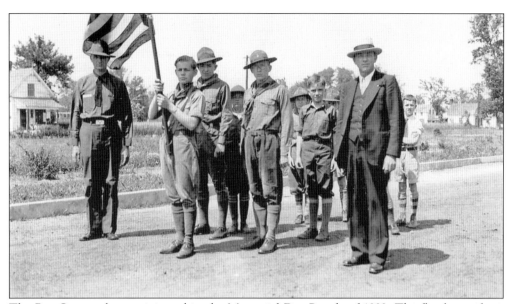

The Boy Scouts also participated in the Memorial Day Parade of 1932. The flag bearer here may be Bill Cherrix and the boy directly behind him is possibly Tom Sturgis. (Courtesy of Ann Coates: the Frances Sturgis Collection.)

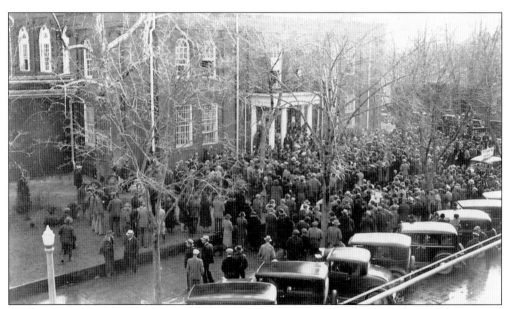

In the 1930s, the Snow Hill Civic Club participated in many initiatives that would improve the town, including working with the mayor and other elected officials on policy and planning. Members of the club are pictured in this photograph outside the courthouse for a drawing for prizes in 1934. (Courtesy of Ann Coates: the Frances Sturgis Collection.)

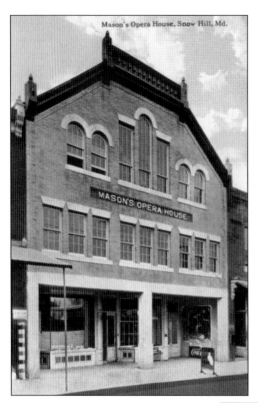

Mason's Opera House, located on Washington Street just north of the courthouse, had a theater upstairs, and Brimer Brothers had a restaurant on the first floor. In the days when the school didn't have an auditorium, school affairs were also held in the theater of the opera house. (Courtesy of Janet Carter.)

This program for the three-act play *Home Acres* dates to 1922. The play was put on at Mason's Opera House to benefit the Snow Hill Volunteer Fire Department. (Courtesy of Kenneth "Bert" Gibbons.)

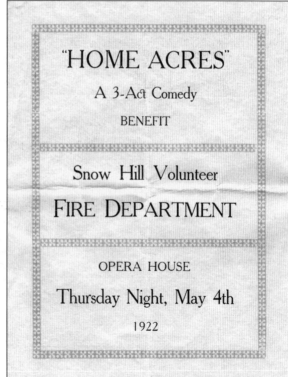

"HOME ACRES"

A 3-Act Comedy

BENEFIT

Snow Hill Volunteer

FIRE DEPARTMENT

OPERA HOUSE

Thursday Night, May 4th

1922

Six

LANDMARKS AND NOTABLE PEOPLE

Snow Hill has its share of significant landmarks left behind by people who made a difference in the community. Additionally the town has spawned citizens who made a mark not only on Snow Hill but on Worcester County, the state of Maryland, and the United States. One such person was William Julius "Judy" Johnson, an African American born in Snow Hill in 1899. Though Judy spent only his childhood in the town, Snow Hill proudly claims him as one of their own. Johnson was the first African American ever admitted to the Baseball Hall of Fame. He played third base in the Negro League in the 1920s and 1930s, but after the racial barriers were broken in American baseball, Johnson scouted and coached for the Philadelphia Athletics. In 1954, he became the first African American coach in the majors when he accompanied the Phillies to Florida for spring training. He worked for the Phillies from 1959 to 1973, and in 1975, through the efforts of the Committee on Negro Baseball Leagues, Judy Johnson was elected to the Baseball Hall of Fame. (Courtesy of National Baseball Hall of Fame Library, Cooperstown, New York.)

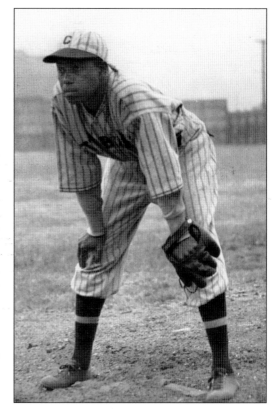

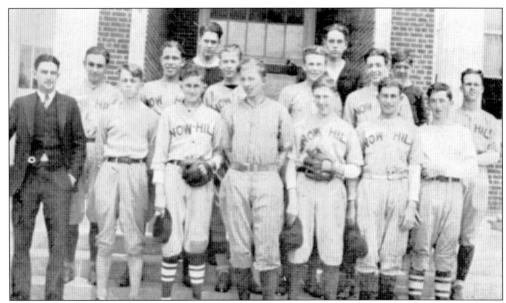

While Judy Johnson was playing in the Negro League, Snow Hill's ball team was playing locally. Shown in this 1931 photograph are Coach Luther Brumley (in suit), Clarence Evans (fourth from left), and Tubby West (third from right in dark shirt). Also included in this photograph are Rob Jackson, Tim Hancock (Jim?), George LeBarnes, Herbert Duer, Marvel Shockley, Charles Nelson, Paul Scarborough, Jim Dryden, and Fulton Duer. (Courtesy of John Layo.)

The existing Worcester County Courthouse was built in 1894, one year after most of the downtown, including the former courthouse, was destroyed by fire. This courthouse was designed by Jackson Gott to resemble Independence Hall in Philadelphia. The cost of building was $23,768. The tower is 65 feet high. (Courtesy of Ann Coates: the Frances Sturgis Collection.)

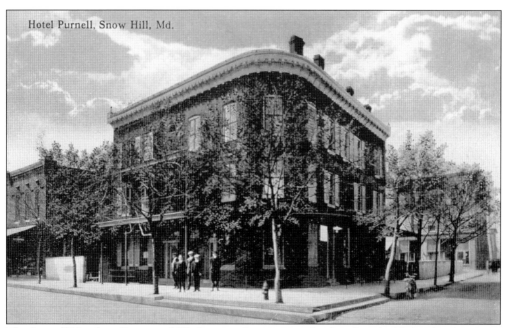

Hotel Purnell, Snow Hill, Md.

The Purnell Hotel on Green and Washington Streets was a landmark embedded in local memory that unfortunately was torn down. Those who still remember the hotel state that it had a beautiful office, marble floors, and a restaurant downstairs. The hotel was often marketed as accommodations for visitors going to Public Landing.

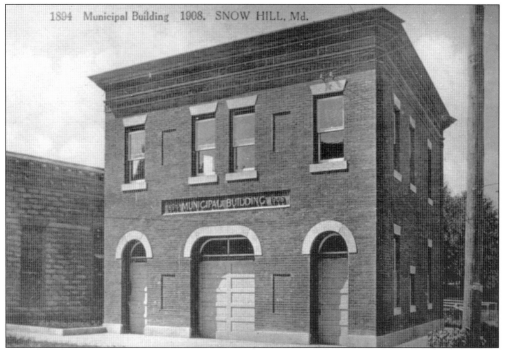

1894 Municipal Building 1908. SNOW HILL, Md.

The Municipal Building, located on Bank and Green Streets, was built shortly after the fire of 1893. It housed the fire company downstairs with a rear door for the fire truck and the town offices upstairs. Today it is used as the town hall. (Courtesy of Worcester County Library.)

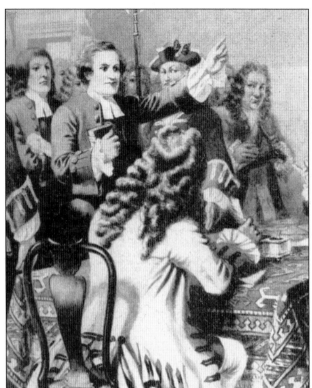

Francis Makemie came to the United States in 1683 and organized the first Presbyterian community in America in Snow Hill, which still thrives today, meeting at the church named for Makemie on Market Street. Makemie was also a national champion for religious freedom in the colonies, shown here testifying at his trial in New York, where he pled for freedom of religion for all in the colonies. (Courtesy of the Reverend Debra Laturre and Makemie Presbyterian Church.)

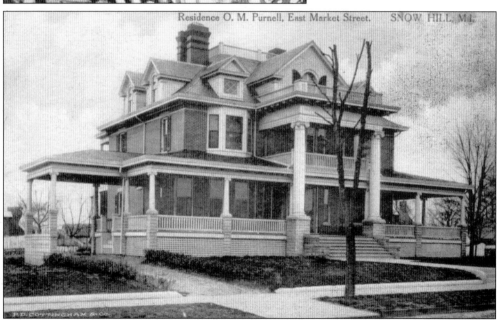

The Oscar M. Purnell House on East Market Street is a dramatic landmark in Snow Hill that sits near the courthouse on the opposite side of Market Street. O. M. Purnell was a prominent businessman in the town, being part owner of the *Democratic Messenger* and a real estate broker. The house currently belongs to Worcester County and is undergoing major renovations. (Courtesy of Janet Carter.)

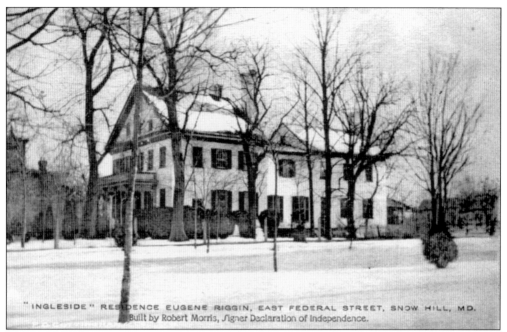

"INGLESIDE" RESIDENCE EUGENE RIGGIN, EAST FEDERAL STREET, SNOW HILL, MD.
Built by Robert Morris, Signer Declaration of Independence.

The portion of Federal Street on either side of Church Street became the place famous for its stately homes, including one of the largest homes in Snow Hill, Chanceford Hall, previously named Ingleside. Built between 1759 and 1795, Chanceford has 5,900 square feet of living space, 10 fireplaces, and an abundance of 18th-century interior detail. It is beautifully restored, and in recent years, it has operated as a bed and breakfast. (Courtesy of Janet Carter.)

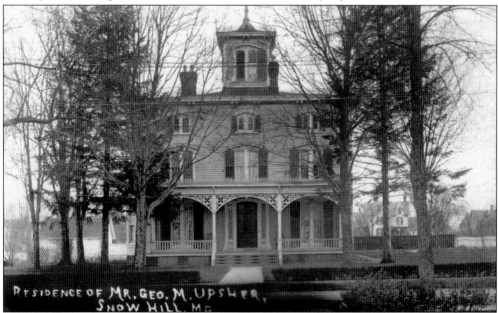

RESIDENCE OF MR. GEO. M. UPSHER,
SNOW HILL, MD

Also on Federal Street is the Hargis House or the William Wilson House, built in 1881 in the Italianate style with cupola. It was built for the son of U.S. senator Ephraim King Wilson (whose residence was one block up on Federal Street). The house was later acquired by businessman M. T. Hargis and remained in his family until the 1950s. (Courtesy of Janet Carter.)

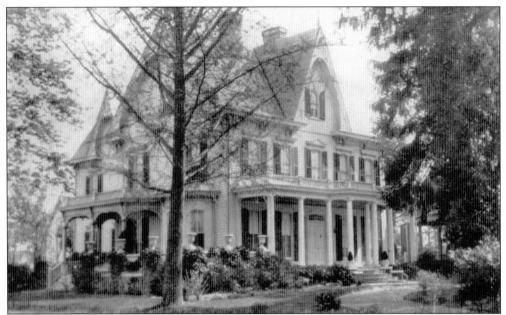

The George S. Payne House, built in 1881 on Federal Street, is not only remarkable because of its exquisite Gothic-style architecture, but also for the memories locals have of the residents who once lived there. George S. Payne, a wealthy merchant, moved into the house and raised his two daughters. He named the house Mapleton. (Courtesy of Janet Carter.)

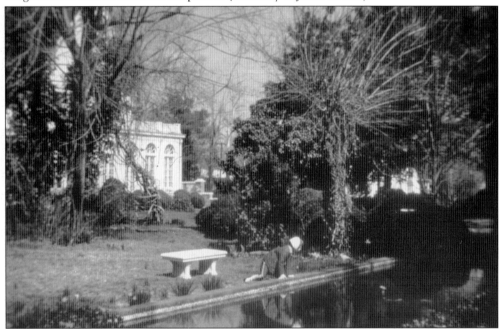

The Mapleton property stretched the entire block between Federal and Martin Streets, and much of it consisted of elaborate gardens. The Payne sisters, who never married, lived in the house all their lives and had a chauffeur named George Allen, who also served as their gardener. The gardens including a fish pond are shown here. (Courtesy of Ann Coates: the Frances Sturgis Collection.)

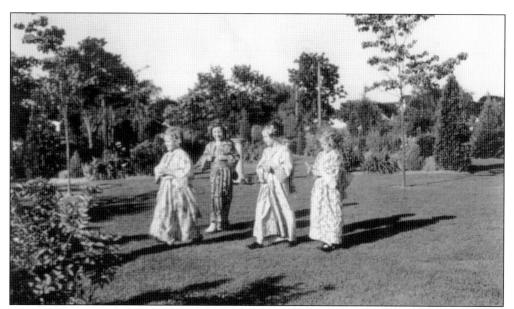

The Payne sisters, Nellie and Annie, hosted many parties that the locals were invited to. This party obviously included children. These young ladies are dressed in Chinese costume for a "garden party" at the Paynes'. (Courtesy of Ann Coates: the Frances Sturgis Collection.)

The gardens around Mapleton were kept up all throughout the lives of the Payne sisters, and they willingly opened them up for use by local citizens. An unidentified young lady is shown walking through the vine-covered pergola. (Courtesy of Ann Coates: the Frances Sturgis Collection.)

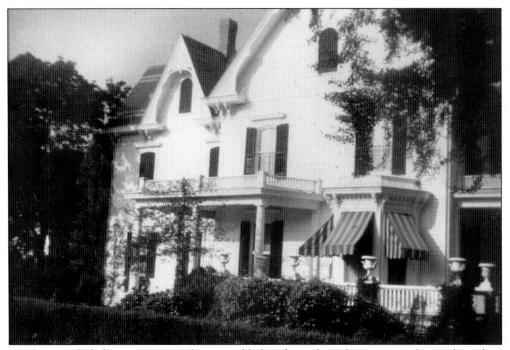

Mapleton included a conservatory that was added in the early 20th century and several porches. Shown here is the side entrance facing Morris Street lined with boxwoods and a privet hedge. (Courtesy of Ann Coates: the Frances Sturgis Collection.)

This photograph shows a little of the gardens where the public was free to roam at Mapleton. The house still stands on the corner of Federal and Martin Streets. It is currently owned and occupied by William W. Pusey, who purchased the property from the Payne sisters' estate. It is where he and his wife, Ellen, raised their family. (Courtesy of Ann Coates: the Frances Sturgis Collection.)

Julia Anne Lecompte Purnell, born in 1843, lived to be 100 years old and left the town of Snow Hill a legacy in art and achievement through perseverance. It wasn't until Julia became disabled at age 85 that she began a hobby of needlework pictures. Eventually she created over 1,000 pieces of needlework, many featuring historic sites in Snow Hill. Her works were circulated throughout the county and state. Her son, William, crafted wooden frames with oak leaves on the corners to display Julia's needlework. William's frames have become an art treasure in their own right. A Purnell frame is highly sought after on the Eastern Shore and brings a hefty price at auctions and antique houses. In her later years, Julia was wheelchair bound but never missed a Sunday at Whatcoat Methodist Church. Her son, William, would pull his automobile up to the front of the church, and four men would carry Julia in her wheelchair into the church and wheel her down the aisle where she sat beside the fourth row. (Courtesy of the Julia A. Purnell Museum.)

The Julia A. Purnell Museum, located on Market Street, is housed in a former Catholic church building. The museum, owned by the Town of Snow Hill, was established by William Z. Purnell in the 1940s as a memorial to his mother, Julia. The museum not only houses a large collection of Julia Purnell's needlework, but also includes many early-American artifacts and interpretive displays. (Courtesy of Janet Carter.)

Julia Purnell began entering her needlework art in hobby and craft shows and won awards as far away as New York and Philadelphia. In 1941, she was inducted in the National Hobby Hall of Fame. Shown is a display of some of her work placed in frames crafted by her son, William. (Courtesy of the Julia A. Purnell Museum.)

Julia Purnell is pictured here with her son, William Z. Purnell, and his wife, Mamie. William's devotion to his mother accelerated the exposure of his mother's crafts as much as her artistic talent. Together they created a legacy, which continues today in the efforts of the museum dedicated to Julia's memory. (Courtesy of the Julia A. Purnell Museum.)

This picture postcard shows an image of a needlework done by Julia Purnell before her death in 1943. The Julia A. Purnell Museum on Market Street houses hundreds more of her needlework projects as well as artifacts and interpretive displays that chronicle the history of the town. (Courtesy of Janet Carter.)

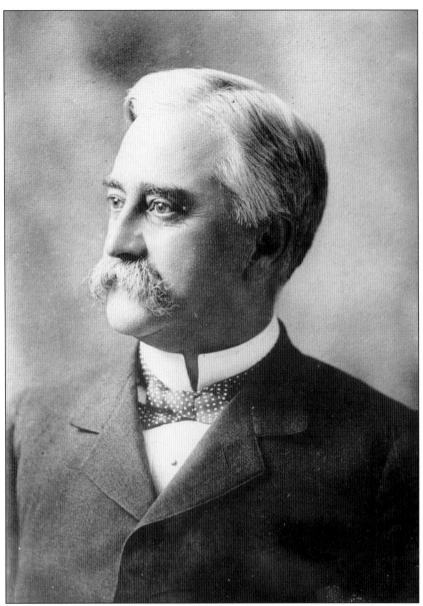

John Walter Smith was born in Snow Hill in 1845 and was the 44th governor of Maryland. He served three terms in the Maryland State Senate, one term as senate president, and 13 years as a U.S. senator. As governor, Smith promoted education, labor, and healthcare reform, reorganized the public school system, and guaranteed free textbooks for all students. Governor Smith also removed the Agricultural College in Maryland from private control and placed it under the state's guidance, where it eventually became the University of Maryland. Smith was an orphan by the age of five but was adopted by state delegate and influential businessman Ephraim King Wilson. Smith was not college educated but went to work straight out of high school as a clerk in a local store of which he subsequently became a partner. That was the beginning of many business successes that include founding the First National Bank of Snow Hill in 1887. His business dealings, which branched into financial sectors, real estate, insurance, and the oyster industry, led to his becoming one of the largest landowners in the county. (Courtesy of the Library of Congress.)

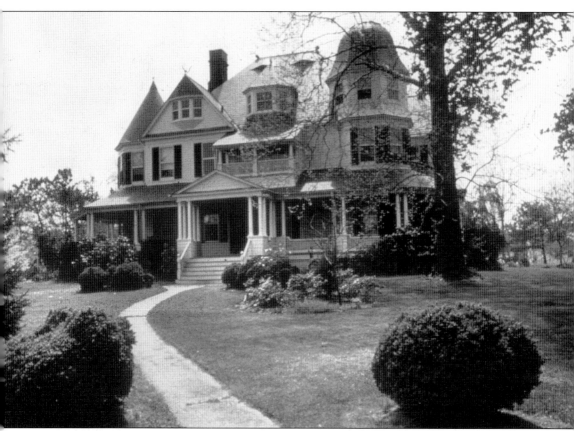

As one of the largest landowners in the United States, John Walter Smith fittingly lived in one of the most remarkable properties in Snow Hill, now called the Governor's Mansion. It was built between 1889 and 1890, shortly before Smith began his two terms as governor of Maryland in 1890. This three-story Queen Anne–style house on the corner of Church and Martin Streets once had an iron fence and gate. The gate was one that mechanically opened as the horses and carriage approached. A carriage house was also located on the property. Jackson C. Gott, the same architect who designed the courthouse and the Purnell Hotel on Washington and Green Streets, designed this house. With 10,000 square feet of living space in over 20 rooms, the Governor's Mansion includes numerous stained-glass windows, oak wainscoting, a sweeping central staircase, and a Tuscan-columned wraparound porch. (Courtesy of Worcester County Library.)

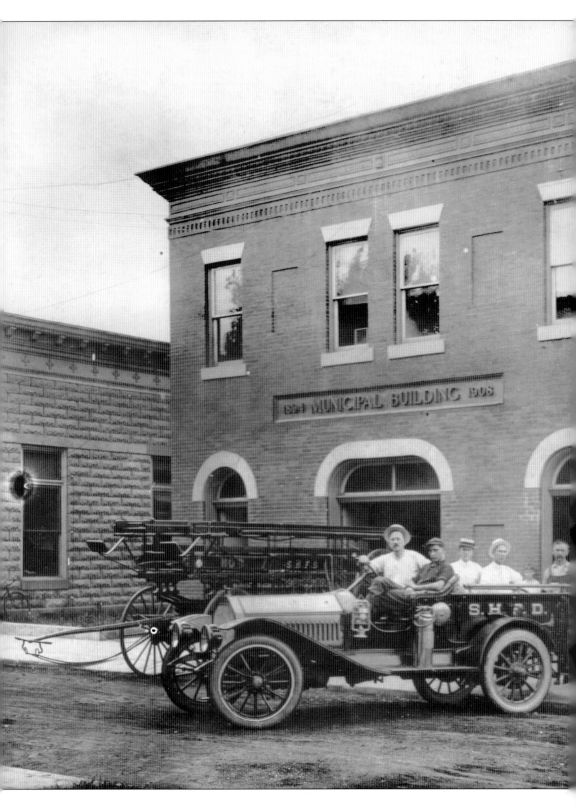

This photograph of the Snow Hill Volunteer Fire Company appears on the cover of the book. Seen here from left to right are Harry C. Bradford Sr., chief James Wilson, Leroy Smith, Charles W. Corddry, Ernest Parsons, Chief of Police H. Esham; Stephen L. Purnell Sr., Nathaniel Pusey, Jesse Goodman, and G. Ewell Dryden. The Snow Hill Volunteer Fire Department was established in 1897, four years after the fire that destroyed the downtown. The department was formed with 28 members and only two hose reels. The Snow Hill station was assigned the number 400. Each station in Maryland has a unique number. (Courtesy of the Julia A. Purnell Museum.)

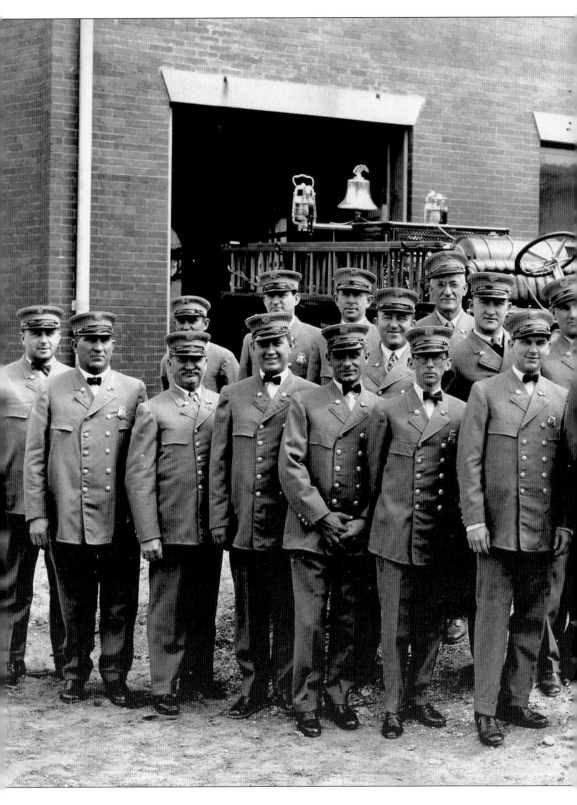

The Municipal Building on Bank and Green Streets was used to house the fire company. In earlier days, the fire company used the back entrance of the building, which had a wide bay door where the truck could be stored, as seen in this photograph. Offices of the mayor, council, and town staff were located on the second floor. The fire truck pictured here is an American LaFrance, chain driven with right-hand steering. This photograph taken in 1927 shows, from left to right, (first row) Andy Hauburt, Herman Adkins, Steve Purnell, Peter King Sturgis, Harry Bradford, William Price (glasses), Edward Wilson, and Ed Deshields; (second row) H. Shockley, John Timmons, Straughn Sturgis, Jesse Goodman, Calvin Hayman, Sam Riley, unidentified, Walter "Hick" Williams, and George Vincent. (Courtesy of the Town of Snow Hill.)

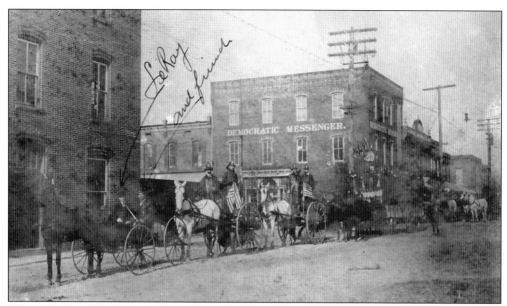

This early shot of the Snow Hill Fire Company was from the William Corddry collection and shows firemen on horse-drawn carts. The carts were used to carry water to the fire. Here they are parading down Market Street in front of Pearl Street. (Courtesy of Rosemary Corddry Manning.)

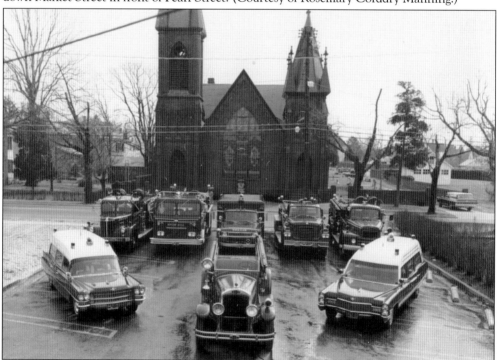

Firemen were trained in fire and rescue through classes offered by the University of Maryland. Fireman Gilbert Perdue became qualified to teach the classes locally so fireman could be trained right in Snow Hill. Several firemen took the classes whenever they were offered, sometimes even repeating the course. Shown are fire vehicles, including two ambulances parked in the lot behind the municipal building. (Courtesy of the Julia A. Purnell Museum.)

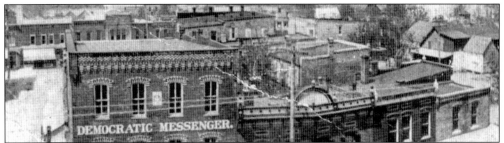

The *Democratic Messenger* was founded in 1867, making it Worcester County's oldest paper. It was published every week in Snow Hill on Thursday. Shown here is the first location for the *Democratic Messenger* on Market Street across from the courthouse. The building displayed the paper's name across the front. The paper was on the first floor, and the telephone company was on the second. The paper has changed names but still survives, now trading as the *Worcester County Times*. The home office is now in Pocomoke City. (Courtesy of John Layo.)

THE LEADING NEWSPAPER OF WORCESTER COUNTY, MARYLAND. LARGEST CIRCULATION EVER ATTAINED IN THIS SECTION

The Democratic Messenger

INCORPORATED

C. L. VINCENT, PRESIDENT C. V. WHITE, SEC. AND TREAS.

Subscriptions Are Due in Advance.
Job Work is Cash.
No Discount Allowed on This Bill.

Snow Hill, Md., April 9, 1921

1921 Mr. Anthony H. Purnell, Berlin, Md. Dr.

April 9 To Publishing advertisement —
30 in. @ 20c. $ 6 00

Advertising was crucial for local businesses as the economy grew in Snow Hill. Shown here is a bill for advertising with the *Democratic Messenger*. The top of the bill touts the newspaper as being "The Leading Newspaper of Worcester County, Maryland. Largest Circulation Ever Attained in this Section." (Courtesy of John Layo.)

Francis Edward Dryden, grandfather of Bert Gibbons, purchased a farm in Whitesburg. The farmhouse is shown here with Norman Dryden (Francis's son) holding the horse. Norman's brother Cletus is standing in the background. A sister, Edna Dryden, was Bert Gibbons's mother. (Courtesy of Kenneth "Bert" Gibbons.)

Eldred Gibbons and his sister, Gladys, are shown in this photograph as children around 1910. They are the children of Edna Dryden Gibbons and the siblings of Bert Gibbons. (Courtesy of Kenneth "Bert" Gibbons.)

Gladys Gibbons, shown in this photograph as an adult, was a schoolteacher all of her life. She is the author of the book *An Itty Bitty History of Snow Hill, Maryland*, which is available for review at the Worcester County Library in Snow Hill. (Courtesy of Kenneth "Bert" Gibbons.)

DeWitt F. Fooks, also known as Frank Fooks, was a member of the Maryland legislature and manager/treasurer of the Worcester County Fertilizer Company. Fooks, born in 1869, also served as mayor of Snow Hill and was known as being large-hearted, genial, kindly, and a faithful friend. Additionally he displayed much enthusiasm and tireless efforts when it came to business, which led him through a prosperous life. (Courtesy of the Town of Snow Hill.)

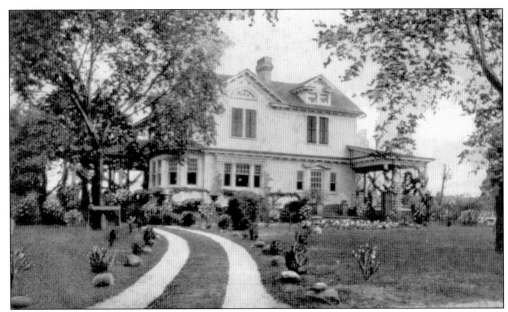

Frank Fooks built a house on Federal Street next door to Mapleton (the George S. Payne House), which he lived in until his death in 1933. His wife and daughter survived him, and daughter Sarah, born in 1928, lived in the house until 2002.

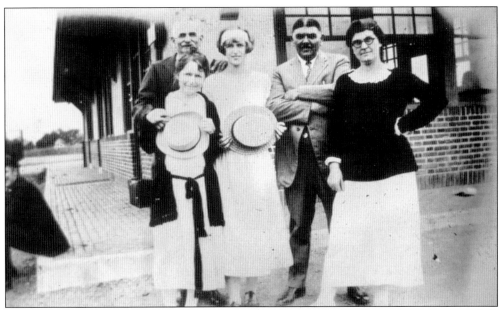

This photograph shows the Fooks family at the Pennsylvania Railroad passenger station on Belt Street in Snow Hill. Frank Fooks (arms folded) and his wife, Molly, are on the right. The names of the other people are unknown. The trains carried passengers, freight, and mail from Snow Hill to Philadelphia twice daily. (Courtesy of Worcester County Library.)

James T. "Jim" Sturgis was born in Snow Hill, lived his entire life in town, and died in Snow Hill. He served as mayor from 1960 to 1974, and Sturgis Park along the waterfront is named after him. Jim worked briefly for Worcester Fertilizer and eventually opened his own fertilizer company and became a successful businessman. He is known as one of Snow Hill's most dedicated and progressive mayors. (Courtesy of Ann Coates.)

Jim Sturgis married Frances Scarborough in 1941, and they moved into Jim's childhood home in Snow Hill, where they remained until their deaths. Jim and Francis chronicled the history of Snow Hill in photographs beginning in the 1930s. It is from their collections that much of this book has been compiled. They were involved in dozens of civic organizations including the Worcester County Historical Society and the Worcester County Garden Club. (Courtesy of Ann Coates.)

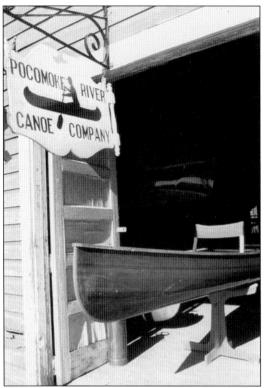

The storage warehouse on the east side of Washington Street is the only surviving building from the Corddry Company. It has been carefully restored by owner Barry Laws and is now the Pocomoke River Canoe Company, which greets visitors as they cross the bridge into town and provides opportunities to rent or purchase canoes and kayaks and explore the scenic Pocomoke River.

Bill Pusey opened a Southern States franchise in Snow Hill, which traded as William W. Pusey and Sons. It supplied feed and farm supplies to local farmers. The store, located on the north side of the river, is now run by Pusey's children and has expanded to be a country store that sells gift items, nursery stock, wine, and more. Pictured are Cyndy Pusey Cunningham and Danny Pusey. Bill Pusey is now retired and continues to reside at Mapleton on Federal Street.

Seven

Public Landing

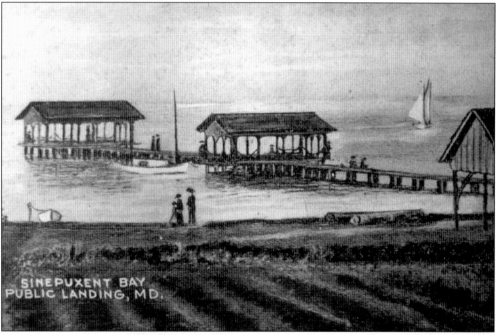

SINEPUXENT BAY
PUBLIC LANDING, MD.

Six miles east of Snow Hill on the Chincoteague Bay lies the quiet village of Public Landing. In the 17th century, Public Landing was part of the Virginia colony, but a readjustment of the boundaries placed ownership with Lord Baltimore and thus back in Maryland. Its location on one of the Coastal Bays made it a prime shipping point for produce, lumber, and shingles, which became its primary industry in the early 19th century, but once the railroad came through, the shipping industry declined. Tourism became the main industry in Public Landing between 1890 and 1933. Swimming, picnicking, fishing, and other recreational activities took hold, and eventually a full-scale amusement park grew over the bay supported by wooden pilings and decking. Tourists that visited the Atlantic beaches on Assateague Island would take a day ferry out to Public Landing for food and amusements. People came by horse, wagons, carts, and later by automobiles to this little village on the bay. Up until its destruction by the 1933 hurricane, Public Landing was a resort that rivaled any on the Mid-Atlantic coast. (Courtesy of Worcester County Library.)

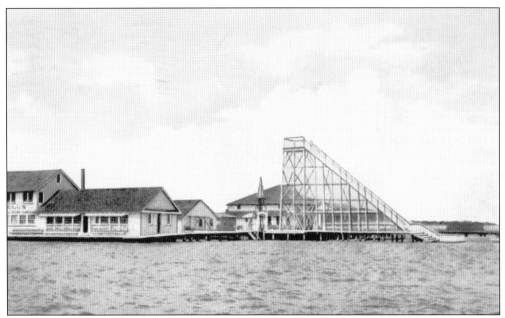

An entire series of amusements that included a large water slide (shown in this postcard photograph), arcade-type games, theater, snacks, food, rides, and more were located in a series of buildings that were built on plank supports out in the bay accessed by rambling boardwalks. People could come by boat or walk in from the beach. (Courtesy of Janet Carter.)

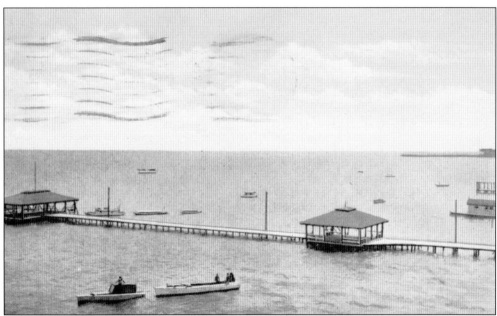

There was a stretch of pier at Public Landing that had three pavilions individually placed. These were popular locations for church picnics, family gatherings, or places where people simply stopped and talked. (Courtesy of Janet Carter.)

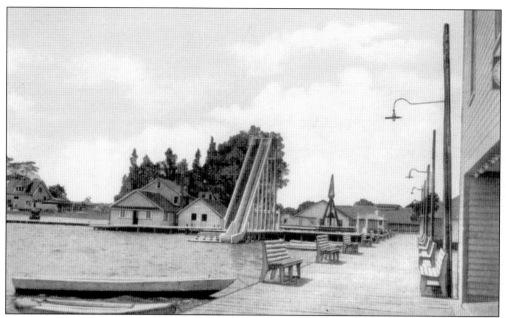

Once the road going into Public Landing (which was an extension of Bay Street in Snow Hill) was paved in 1923, the amusements and attractions grew. A large pier with a dance hall was built to go with the theater, concessions, and bowling alley. (Courtesy of Janet Carter.)

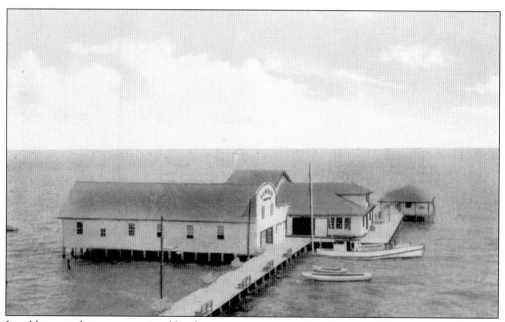

In addition to being entertained by the amusements, people still engaged in recreation that had been associated with the water prior to man-made entertainment. Crabbing, clamming, fishing, picnicking, boat rides, and swimming were always a part of the fun at Public Landing. (Courtesy of Janet Carter.)

Public Landing had a "moving picture" theater, a bowling alley, pool tables, and a merry-go-round. Virginia Sturgis told of a game at Public Landing called a "Walking Charlie," a shooting gallery–type game where you try to shoot a little man (Charlie) as he bobs and weaves away from you. (Courtesy of Ann Coates: the Frances Sturgis Collection.)

One common theory (not proven) of how Public Landing got its name was that it was where the people from the barrier islands, such as Chincoteague, landed or were dropped off and picked up when going to and from their island homes. Shown is this photograph is Purnell's Soda Fountain in the 1930s. (Courtesy of Ann Coates: the Frances Sturgis Collection.)

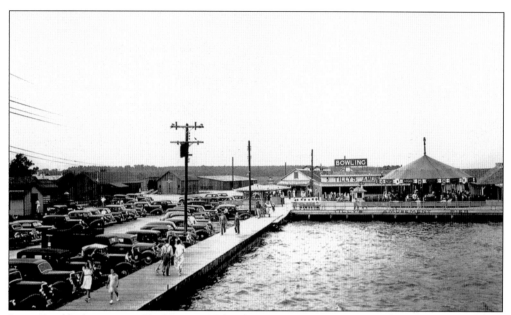

Laura Bradford was quoted by Victoria Heland in *Worcester Memories* as saying, "People would go and they'd pack up a great big mess of food, and go there, and eat, and then they'd pack up what was left and bring it down here. . . . And they'd park clear down the roads." This photograph was taken in 1937 after Public Landing was destroyed by the storm of 1933 and features the new pier that was built closer to the beach. (Courtesy of Ann Coates: the Frances Sturgis Collection.)

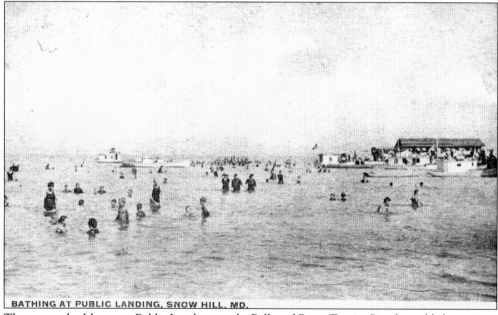

There was a bathhouse at Public Landing run by Polk and Betsy Turpin. People could change into bathing wear out of their regular clothes and go for a swim. For those who didn't have a bathing suit, the Turpins would rent one for 10¢, which would be hung to dry after use and immediately used for the next customer. (Courtesy of Worcester County Library.)

This advertisement appeared in the *Democratic Messenger* in July 1929 touting the new Public Landing "with an all concrete road . . . where it is always cool." While it also advertises the amusements, it also highlights a "nice place to eat" with free tables. (Courtesy of Huey Brown.)

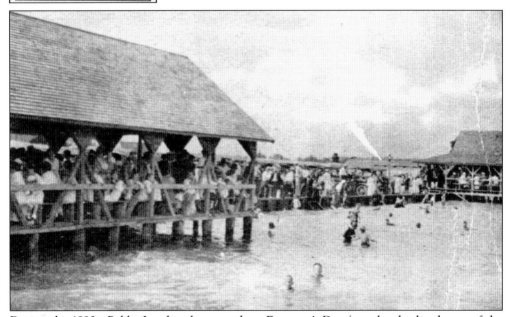

During the 1890s, Public Landing began to host Forrester's Day (people who lived west of the Pocomoke River were called Forresters). Every first Thursday in August, families, mostly from farms, would leave their fields and travel the distance, which sometimes took six to eight hours, to Public Landing for Forrester's Day, later named Farmers Day. This tradition continued into the 1920s and eventually would attract over 1,000 people. (Courtesy of Janet Carter.)

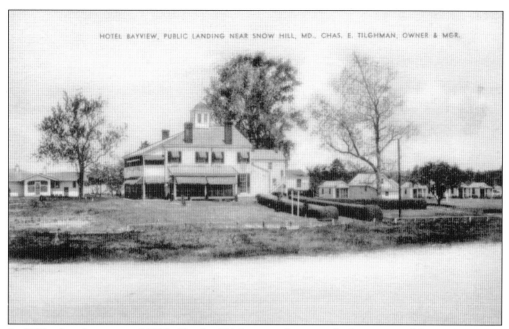

In 1937, after the storm of 1933, Charles Tilghman, who owned a large part of the previous pier amusements and concessions, converted a home on the waterfront into a hotel, naming it the Bay View Hotel. Many little homes were also built along the shore as cottages owned by the hotel to rent out, and part of the pier and amusements were restored. World War II followed shortly after, and the amusements were closed and never reopened. (Courtesy of Janet Carter.)

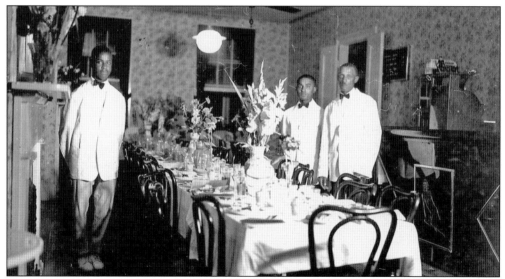

The Bay View Hotel rented rooms by the day or week and also rented out cottages. Rooms with meals were $4 per day or $20 per week. Cottages rented for $15 per week. The dining room in the Bay View Hotel served breakfast, lunch, and dinner for between 60¢ and $1 per meal. The dining room with waiters is shown in this photograph. The table is set for a party. (Courtesy of Ann Coates: the Frances Sturgis Collection.)

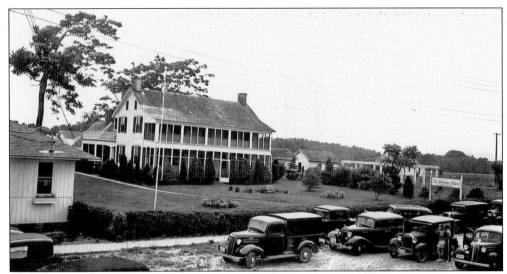

The oldest residence in Public Landing is the Mansion House that was home to Judge Ara Spence and included hundreds of the surrounding acres. Judge Spence died in 1886, and the Mansion House was eventually turned into a resort hotel. (Courtesy of Ann Coates: the Frances Sturgis Collection.)

With its tall trees, two-story galleries, and water views, it's easy to see why the Mansion House was so attractive to visitors who came to Public Landing. Today the house occupies the same location, is immaculately restored, and still operates as an inn for travelers who want to step back in time and experience the beauty of this waterside village. (Courtesy of Janet Carter.)

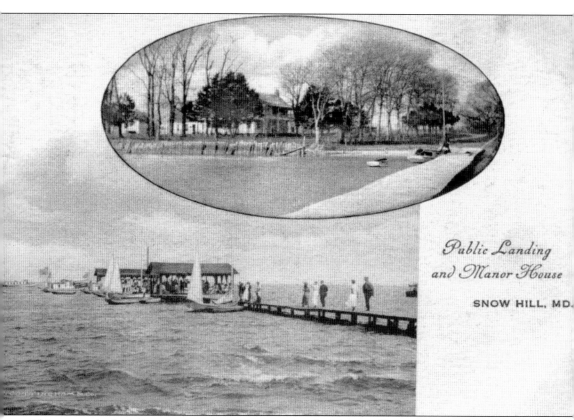

Public Landing
and Manor House

SNOW HILL, MD.

This postcard, which dates back to the 1930s, promotes the Mansion House, showing the peaceful setting of the house against the pier with pavilions, boats, and vacationers. The storm of 1933, which devastated the Atlantic coast, destroyed Public Landing, and it never returned to the glory it experienced in the early part of the 20th century. The water level rose—some say 10 feet—and simply swept the venue away, reducing most of the buildings to wood splinters resembling matchsticks piled up. It is said the painted horses from the carousel were found washed up on beaches all along the coastal bay area. (Courtesy of Janet Carter.)

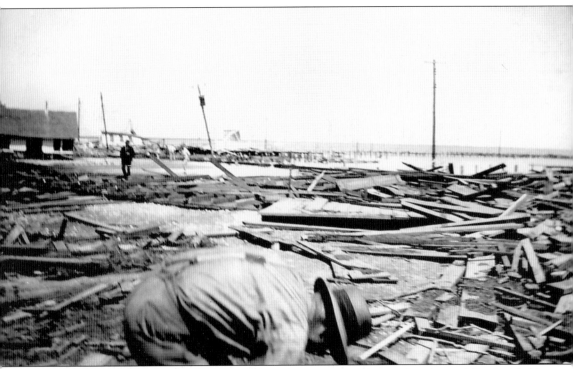

Leland Richardson ran the bowling alley and ice cream parlor on the pier and lived with his family in an apartment above the bowling alley in the summer months. His daughter, Esther Evans, recalls playing the piano for the silent movie theater. She also recalls the great storm of 1933, as she and her family were in the apartment riding out the storm until they began to feel the pounding of the water beneath their floorboards. They grabbed what they could carry and began making their way down the pier to land in the throes of the hurricane. The pier was slipping out from under them as they made their way, but fortunately they all made it to land. Moments later, they watched as the pier was torn apart. All of the buildings, piers, pavilions, and amusements were destroyed, and though there were several efforts to revive Public Landing, nothing matched the glory days of the 1920s and early 1930s. (Courtesy of John Layo.)

Eight

SNOW HILL GHOSTS

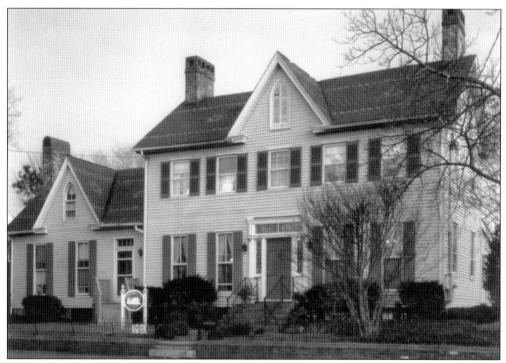

Like many towns, Snow Hill has its stories of ghosts and unexplained events, but two stories are worth retelling. One is called "The Cellar House," a story that has been told and retold by local people in six counties for generations, and the other is "The Snow Hill Inn," where scores of people have experienced paranormal activity and which has been covered by National Geographic television network. Pictured is the Snow Hill Inn, *c.* 1835, located on Market Street. Dr. John Aydelotte, who practiced medicine in Snow Hill for 60 years, lived in the home with his wife, Delia. They had a son, William, and a daughter, Mildred. The inn is said to be haunted by William, who allegedly committed suicide in 1904 at age 21 in a Baltimore boarding house after realizing he was failing out of pharmacology school. He penned a note to his father that said, "Dear Papa, it is useless to keep me at school." *The Baltimore Sun* reported, "Mr. Aydelotte had evidently cut his throat while standing in front of the bureau. He is then believed to have walked to his bed and cut his throat twice again." Descendants of the Aydelottes have often questioned the circumstances of young William's death.

The *Sun* also reported that William was ill—too ill to study. The article also reveals a "young lady" in Westminster with whom William had been corresponding, and the exchange was abruptly discontinued. Then there are hints that the friendship between William and his Westminster lady friend had recently been renewed. Speculation causes a body to wonder what (or who) really drove William over the edge. Dr. Aydelotte, pictured, never knew, or did he? (Courtesy of Margaret Aydelotte Young.)

Nothing is ever said about William's heartbroken mother, Delia, pictured. We know she lived to be 92 and is buried beside her husband and son in Whatcoat Cemetery. Her son-in-law, George Walter Mapp (married to Mildred), was quoted in a 1993 follow-up article by *The Baltimore Sun* as saying of the tragedy, "We never believed he killed himself." (Courtesy of Margaret Aydelotte Young.)

Innkeepers, contractors, guests, children, employees, and locals all have stories of the young man who roams the halls of the inn, locking doors, opening windows, turning lights off and on, setting fire alarms, appearing in mirrors, shaking beds with sleeping guests in them, extinguishing candles, lighting the fireplaces, and more. Whether William (shown here) killed himself for fear of disappointing his father or was done in by someone who wanted him gone, many today believe his unrestful spirit haunts the Snow Hill Inn. (Courtesy of Margaret Aydelotte Young.)

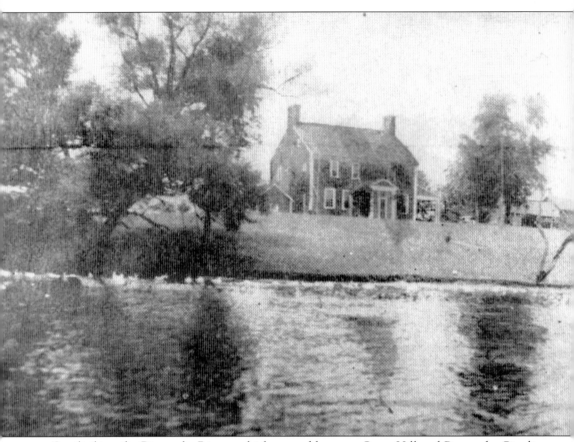

Overlooking the Pocomoke River on high ground between Snow Hill and Pocomoke City lies Cellar House, so named because of a legendary tunnel that went from a trap door in the house out to the river, making it easy for pirates to smuggle goods. Legend also states that the house was built by a French sea captain for his bride and that he returned home unexpectedly early to discover his bride with child by another man. He threw his wife out, but she returned by raft with her baby months later to beg his forgiveness. The raft overturned and the baby drowned. The captain dragged his wife from the water to the bedroom where he stabbed her to death, and knowing he would be hung for the crime, the captain fled and never returned. It is said that when the woman's body was discovered, it left a permanent imprint that could not be removed by cleaning. The floorboards were replaced, and on nights when the wind whips up the river, the screams of the baby can be heard crying for his murdered mother. The photograph above is an old picture of Cellar House. It has since been beautifully restored and can be visited upon request. (Courtesy of Worcester County Library.)

BIBLIOGRAPHY

Burgess, Robert H. *This Was the Chesapeake Bay.* Centreville, MD: Tidewater Publishers, 1963.

Burton, R. Lee Jr. *Canneries of the Eastern Shore.* Centreville, MD: Tidewater Publishers, 1986.

Daily Times/Salisbury Times. Salisbury, MD. 1933–1987.

Democratic Messenger/The Worcester County Times/The Snow Hill Express. Snow Hill, MD, and Pocomoke City, MD; 1957–1985.

Gibbons, Gladys I. *An Itty Bitty History of Snow Hill, Maryland.* Snow Hill, MD: Worcester County Library and the Gibbons family, 1970.

Harris, Edward P. "Snow Hill during the Period of 1945 to 1940 as Remembered by Edward P. Harris." Unpublished memoir provided by J. Huey Brown, Snow Hill, MD: n.d.

Heland, Victoria J. *Worcester Memories 1890–1933.* Snow Hill, MD: Worcester Heritage Committee, 1984.

Kensey, Charles Cleveland. "I Remember Steamboat Days on the Pocomoke." Baltimore, MD: *The Baltimore Sun Sunday Magazine,* March 13, 1966.

The Eastern Shore of Maryland and Virginia, Personal and Family Records, Volume III. New York: Lewis Historical Publishing Co., Inc., 1950.

Torrence, Clayton. *Old Somerset on the Eastern Shore of Maryland.* Baltimore, MD: Regional Publishing Company, 1966.

Touart, Paul Baker. *Along the Seaboard Side, The Architectural History of Worcester County, Maryland.* Snow Hill, MD: Worcester County Commissioners, 1994.

Truitt, Dr. Reginald V. and Dr. Maillard G. Les Callette. *Worcester County: Maryland's Arcadia.* Snow Hill, MD: Worchester County Historical Society, 1977.

Oral commentaries from Huey Brown, Virginia and Charles Nelson, Kenneth "Bert" Gibbons, Bill and Blanche Williams, Gus Payne, Virginia Sturgis, Emma Scarborough, Janet Carter, John Layo, and Ann Coates, all of Snow Hill, Maryland; and oral commentary from Rosemary Corddry Manning of Salisbury, Maryland.

All photographs with no credits given are from the author's personal collection.

ACROSS AMERICA, PEOPLE ARE DISCOVERING SOMETHING WONDERFUL. *THEIR HERITAGE.*

Arcadia Publishing is the leading local history publisher in the United States. With more than 3,000 titles in print and hundreds of new titles released every year, Arcadia has extensive specialized experience chronicling the history of communities and celebrating America's hidden stories, bringing to life the people, places, and events from the past. To discover the history of other communities across the nation, please visit:

www.arcadiapublishing.com

Customized search tools allow you to find regional history books about the town where you grew up, the cities where your friends and family live, the town where your parents met, or even that retirement spot you've been dreaming about.